T0353606

# AI FOR ARTS

# AI FOR EVERYTHING

Artificial intelligence (AI) is all around us. From driverless cars to game-winning computers to fraud protection, AI is already involved in many aspects of life, and its impact will only continue to grow in the future. Many of the world's most valuable companies are investing heavily in AI research and development, and not a day goes by without news of cutting-edge breakthroughs in AI and robotics.

The AI for Everything series will explore the role of AI in contemporary life, from cars and aircraft to medicine, education, fashion, and beyond. Concise and accessible, each book is written by an expert in the field and will bring the study and reality of AI to a broad readership, including interested professionals, students, researchers, and lay readers.

**AI for Immunology**
Louis J. Catania

**AI for Cars**
Hanky Sjafrie & Josep Aulinas

**AI for Digital Warfare**
Niklas Hageback & Daniel Hedblom

**AI for Creativity**
Niklas Hageback

**AI for Fashion**
Anthony Brew, Ralf Herbrich, Christopher Gandrud, Roland Vollgraf, Reza Shirvany & Ana Peleteiro Ramallo

**AI for Death and Dying**
Maggi Savin-Baden

**AI for Radiology**
Oge Marques

**AI for Games**
Ian Millington

**AI for School Teachers**
Rose Luckin & Karine George

**AI for Learners**
Carmel Kent, Benedict du Boulay & Rose Luckin

**AI for Social Justice**
Alan Dix and Clara Crivellaro

For more information about this series please visit:
https://www.routledge.com/AI-for-Everything/book-series/AIFE

# AI FOR ARTS

NIKLAS HAGEBACK
DANIEL HEDBLOM

CRC Press
Taylor & Francis Group
Boca Raton London New York

CRC Press is an imprint of the
Taylor & Francis Group, an **informa** business

First Edition published 2022
by CRC Press
6000 Broken Sound Parkway NW, Suite 300, Boca Raton, FL 33487-2742

and by CRC Press
2 Park Square, Milton Park, Abingdon, Oxon, OX14 4RN

© 2022 Niklas Hageback, Daniel Hedblom

CRC Press is an imprint of Taylor & Francis Group, LLC

*Library of Congress Cataloging-in-Publication Data*
Names: Hageback, Niklas, author. | Hedblom, Daniel, author.
Title: AI for arts / Niklas Hageback, Daniel Hedblom.
Other titles: Artificial intelligence for arts
Description: First edition. | Boca Raton : CRC Press, 2021. |
Series: AI for everything | Includes bibliographical references and index.
Identifiers: LCCN 2021012186 | ISBN 9781032048819 (hbk)|
ISBN 9781032048802 (pbk) | ISBN 9781032048802 (ebk)
Subjects: LCSH: Art and technology. | Art—Psychology. | Artificial intelligence.
Classification: LCC N72.T4 H34 2021 | DDC 701/.05—dc23
LC record available at https://lccn.loc.gov/2021012186

ISBN: 978-1-032-04881-9 (hbk)
ISBN: 978-1-032-04880-2 (pbk)
ISBN: 978-1-003-19500-9 (ebk)

Typeset in Joanna
by codeMantra

# DEDICATION

*To Aarik, Bernard & Cherry*

# CONTENTS

# AUTHORS

**Niklas Hageback** has an extensive background in digital transformations and risk management. He has held regional executive management and project oversight roles at leading banks, including Credit Suisse, Deutsche Bank, and Goldman Sachs, in both Asia and Europe, where he was in charge of a number of complex regionwide digital transformation and risk management initiatives. More recently, he has done extensive work in Artificial Intelligence, notably machine learning, leading the development of automated human reasoning and computational creativity applications. He is a published author with bestsellers including *The Mystery of Market Movements: An Archetypal Approach to Investment Forecasting and Modelling* (2014), *The Virtual Mind: Designing the Logic to Approximate Human Thinking* (2017), *The Death Drive: Why Societies Self-Destruct* (2020), *and Leadership in the Digital Age: Renaissance of the Renaissance Men* (2020). He has also published a number of research papers in AI and finance.

**Daniel Hedblom's** background includes working as a senior artificial intelligence consultant developing data warehouses, data analytics, and visualization tools. His focus has been on designing predictive analytic systems and models for financial markets and replicating consumer purchasing patterns with a core competence in the understanding and execution of the full project life cycle, and in particular database and data flow designs.

# INTRODUCTION

L'âme se peint dans nos machines
The soul paints itself in our machines.
> Joseph Joubert, French moralist & essayist (1754–1824),
> Pensées, essais, maximes et correspondance de J.

Expressing oneself in art appears to be an integral part of human life, and cave paintings are one of the earliest known traces that remain of our ancestors. But what is art really? Why is it so important to us, as it does not seem necessary for mere survival, yet its many formats play such a great role in our lives that it would be difficult to fathom a world void of it. Whilst the styles of art, through the multitude of ways it manifests, do fluctuate, there are some common denominators that reverberate and transcend cultures and time epochs, particularly the representations of the human condition and our reflections on the timeless question of life and death.

Enter artificial intelligence, perhaps soon as clever or even more so than us humans, but without the eternal spiritual ponderings on the meaning of life that are so fundamental in defining who we really are and play a decisive role in governing our behaviour, albeit often in ways beyond our comprehension. So, what does it do to art in its plethora of expressions when artificial intelligence can technically produce it better than us, but lacking the dimension that includes the elusive concept of a soul? *AI for Arts* is a book for anyone fascinated by the man–machine connection, an unstoppable evolution that is intertwining us with technology in an ever-greater degree, and where there is an increasing concern that it will be technology that comes out on top. Thus, presented here through perhaps its most

esoteric form, namely art, this unfolding conundrum is brought to its apex; what is left of us humans if artificial intelligence surpasses us also when it comes to art? The articulation of an artificial intelligence art manifesto has long been overdue, so hopefully this book can fill a gap that will have repercussions not only for the aesthetic and philosophical considerations but possibly more so for the trajectory of artificial intelligence. *AI for Art* is structured in four chapters.

## CHAPTER 1: WHAT IS ART AND WHY ART MANIFESTOS?

This chapter goes to the core of what art is and why it is so intrinsically linked with what it means to be a human. History is full of examples of us humans going to great lengths in our urge to express ourselves artistically, even to the point of risking our lives. Over the different time epochs, art has been evolving where new ways of depicting the world and ourselves have taken alternate shapes and forms. These have often been articulated through art manifestos, a public declaration of the motifs and techniques that are applied and practiced to provoke a paradigm shift to refocus on what is important in the contemporary setting, not unusually including a political slant that seeks to change a culture or society that appears stagnated and obsolete.

## CHAPTER 2: THE HUMAN EDGE: WHY OUR WEAKNESS MIGHT BE OUR STRENGTH IN THE BATTLE AGAINST MACHINES?

Few argue that artificial intelligence is now changing the world as we know it, both in ways we can fathom and observe but also through unforeseen consequences that perhaps some of us can speculate about, but no one really can yet fully oversee. Broadly applicable on most human endeavours, artificial intelligence is, in various degrees, replacing the need for human input, or at least complementing it through the man–machine connection. The optimists see that

humans at large will continue to be in control over technology; the pessimists, however, are taking the reverse point of view. But here an interesting insight is emerging: our greatest perceived weakness, irrationality, might prove to be our strength in the battle against machines.

## CHAPTER 3: HOW ARTIFICIAL INTELLIGENCE INFLUENCES ART

Artificial intelligence has already made its entrance in the many facets of art, from the different forms of writing, including prose and poetry; the composition of music; and the production of movies, photography, and painted art. This chapter provides an insight on the current status of machine-generated artforms, its consequences and what can be expected in the near future as its potential starts to be realised in a fuller extent.

## CHAPTER 4: THE ARTIFICIAL INTELLIGENCE ART MANIFESTO

Strangely enough, an art manifesto intent on considering the impact of artificial intelligence not only for artistic manifests but society at large has yet to emerge. Why is that? At its root stands the human species' position in the world, now seen as threatened by an emerging technology that is challenging our very existence; however, we have kind of been here before.

With the advent of industrialism, man was, for the first time, really confronted by and compared with machines. In the factories, we were often seen as merely another cog in the wheel. The confusion and stress it caused created a public disquiet that spanned across the fabrics of society, something that was not lost in the contemporary artist communities rendering the publication of numerous art manifestos seeking to illustrate and help humanity handle this new reality with its unique challenges. Taking the starting point from this first uneasy meeting between man and machine and how the illustrious artisans

of the day sought to mend ways and present art as the forum to overcome the challenges, or at least comprehend it, the authors approach our current unprecedented encounter with machines of an even more existential nature by formulating an artificial intelligence manifesto.

The book concludes by leaving the readers with some key takeaways and reflections of the brave new digital world and suggestions on how art should be the conduit to seek a meaningful co-existence, something perhaps best articulated through an art manifesto.

# 1

## WHAT IS ART AND WHY ART MANIFESTOS?

Art is the lie that enables us to realize the truth.

Pablo Picasso, Spanish artist (1881–1973)

What is art really and why does it appear to be so tightly linked with what it means to be a human? We are the only mammal species that produces art, and while it is important to us, it is in no way necessary for our physical survival. Still, the examples are numerous on how humans have risked, even sacrificed, their lives for the right to express themselves artistically. Art comes in many forms, from literature with its prose and poetry to sculptures and paintings, movie making, the composition of music, but also bodily expressions such as dance. But what is it that we seem so eager to express through art? By studying the various artworks over the millennia, a few themes keep appearing, namely that of expressing the human condition and our sometimes anxious deliberations over life and death, including the existence of a soul and similar ethereal phenomena. These are typically depicted in a contemporary setting, sometimes through metaphors that in particular will resonate with its intended audience, which will come in variations, and the many manifests of art do take different shapes and forms over time, culture, and geography,

and in the past at least, they also came with requirements of aesthetic minimum standards.

Beyond its typical timeless motifs, what is art then? A distinction and clear delineation need to be made between understanding why art is so important to us, or a "theory of art", and how to define works of art. On the question of the latter, something which the provocative artist Marcel Duchamp (1887–1968) more than a century ago brought to a culmination by proclaiming his porcelain urinal to be art and it is a topic that still divides the general public. Mired in the attempt of defining art lies the challenge of how to qualitatively rank it. The concept *beauty is in the eye of the beholder* can in its free-spirited mode qualify pretty much anything as art, but that is a far too complacent approach and brings little of actual insight in understanding art. Art was for long equated with beauty; certain standards in terms of colour compositions and the golden ratio for paintings, absolute pitch and perfect harmony in music, and the hexameter for writing poetry are examples artists were expected to comply with. By applying such meticulous standards, art could be assessed from a qualitative perspective; some poets mastered the hexameter better than others and this could be quite precisely gauged. It typically required a highly deliberate effort for something to qualify as art and it took years of intense training to become an acknowledged artist and accepted by a guild. Art was produced, amongst others, to decorate our surroundings, this as beauty was seen to elevate man to aspire for higher ideals, through improvement and empowerment, possibly with the ambition of seeking to equate oneself with the gods. Indeed, skilful artists were seen as being bestowed with divine gifts and inspiration to be able to produce admirable art. In that sense art was a medium to communicate celestial matters, extending to understanding what the divine forces had in mind for us humans, possibly providing a privileged peak into a highly uncertain future where death was always lurking around the corner. Interestingly enough, and something that will be elaborated on later, to achieve this divine status seen as a pre-requisite to be able to produce noteworthy art, the artist had to enter a state of mind that transcended beyond merely rational qualities.

Aside from the delicate notion of what constitutes good versus bad taste and if that is something that transcends different time epochs and cultures, to at least be able to orient oneself around what art is, there are various criteria that provide an understanding of the characteristics and production techniques it should include. Presented below is one of such standards, albeit these are far from commonly agreed upon, to which it is thought that by, in the broadest sense, achieving these, a work of art can be considered to have been created:

- possessing positive aesthetic qualities
- being expressive of emotion
- being intellectually challenging
- being formally complex and coherent
- having a capacity to convey complex meanings
- exhibiting an individual point of view
- being an exercise of creative imagination
- being an artifact or performance that is the product of a high degree of skill
- belonging to an established artistic form, and
- being the product of an intention to make a work of art[1]

Thus, through standards like this, and whilst coming with considerably blurred boundaries, at least a superficial understanding of what might constitute an artwork and against what yardsticks it should be judged do provide some distinct guidelines.

Of greater importance and for the purpose of this book, however, is the question of why art is so crucial to us humans, as that reflection can act as an apt catalyst to give a glimpse of our cognitive and psychological make-up vis-à-vis the construction of an emerging generation of artificial intelligence. A formal understanding might not be required but rather an acknowledgement of the rationale of what function art serves.

A possibly fruitful conduit to explore this conundrum is by conducting a study of art manifestos as new directions in art have often

been heralded and articulated through these. Art manifestos are public broadcasts of the motifs and techniques that are applied and practiced with a view to incite and prompt a paradigm shift that seeks to re-focus on what it is that is (aesthetically) important in the contemporary setting. Basically, it serves as a declaration that proclaims a new way to view the world, not unusually with an embedded political twist aspiring to change a culture or society that appears stagnated, detrimental, or outright obsolete. At times, art manifestos have only been implicitly stated and not arranged into a single document; yet their broader ambitions and gist were still well understood, and both endorsed and adhered to by influential circles of artists, eventually reverberating across broader segments of society. The typical art manifesto consists of a series of statements, not always listed in a sequential and inferential order, highlighting the key tenets of the artistic movement, including how it should be technically represented, as well as announcing what this particular movement is against, usually something in the current state of affairs, and finally the new avant-garde perspective it desires artists to rally around. Thus, art manifestos serve two main purposes: a criticism of what its originators consider is wrong with contemporary art or other societal ails and a provision of artistic remedies. From the 20th century onwards, many of the art manifestos were dominated by political and social doctrines, often trying to promote their point of views through provocations and dramatic effect, not seldom going against what was for the time considered good taste. Rather than subtly influencing cultural and political trends, a more confrontational revolutionary approach was often the preferred modus operandi, and these art manifestos have been distinctly anti-capitalist, left leaning with broadly defined anarchist tendencies.[2,3,4]

Coinciding with the emergence of industrialism that embraced most Western societies from the late 19th century onwards, art movements, such as *Cubists* and *Dadaists*, started to challenge the requirement that art per definition had to be beautiful. These art styles emphasised political ambitions by in particular taking aim at the negative sides of industrialism and capitalism, seeking to alter

the existing cultural and political societal arrangements. Protesting against bourgeois convention became one of their favourite targets, attacking them through what they knew was perhaps what was they considered most annoying, namely producing and presenting art that fell outside the accepted conventions of beauty, and at times, greatly so.[5]

Over time, and especially from the Second World War onwards, hardly any contemporary art piece can be said to be considered beautiful, at least not according to the traditional standards. Important to note, this deviation has largely been deliberate rather than a drop in quality, albeit the view that anything can be considered art has attracted a considerable number of second-rate talents to the profession. However, the original impetus was prompted through new artistic ways to consider the world with the perhaps most important trigger being our species' first encounter with machines, and how we humans started to be gauged against them. These avant-garde art movements began to challenge, and probably rightfully so, the mere decorative aspect: should arts only purpose be beauty? Is it not more important to raise awareness and inspire humans to seek to change what was wrong with their contemporary world? And if provocations and bad taste was what it took, so be it.

Therefore, art was starting to serve a different purpose, and it was likely due to the dramatic economic, cultural, psychological, and social standards that industrialism brought with it. With the advent of industrialism, man was for the first time really confronted by and compared with machines, in the factories, workers were metaphorically likened to being just another cog in the wheel, one easily replaced by another. The view of the consumers was much the same, standardised goods for standardised people, today best remembered through Henry Ford's marketing slogan "Any customer can have a car painted any color that he wants so long as it is black".

Artists with a social pathos took to this challenge, realising an existential foreboding on how the human race should respond in this unsettling environment where the positions and value, and in extension the very existence, had to be drastically re-configured. The

confusion and stress this paradigm shift caused created a public disquiet that span across the fabrics of society; this psychological sentiment was not lost on the contemporary artist communities which rendered the publication of numerous art manifestos seeking to guide humanity through art to handle and overcome this new reality with its unique challenges.

The era of industrialism brought with it a plethora of transformational changes spanning across the many aspects of life, not only affecting work. Industrialism triggered an urbanisation of an enormous scale, where workers in the factories had to live in cramped conditions in tenement estates in the quickly growing cities; however, it was not all gloomy as it brought with it features of modernity such as electricity, water accessible from taps, and so on. Urbanisation came with a drastic change in social life; gone were the tightly knit villages with their gossip and social ties, and the big cities provided anonymity and gave an element of freedom, away from traditional norms and morals. This anonymity came to be a prominent feature in much of the literary work that highlighted the challenges of loneliness and finding one's place in a world as well as one's value. Compensation for work now came in the form of money, instead of produce, which gave increased opportunities to spend the money on the goods and services one preferred, and simultaneously the supply increased enormously. Labour was also being more comprehensively regulated, where fixed working hours became a standardised feature, which allowed for free time where one could engage in hobbies and extracurricular activities. In effect, it meant individualisation for a larger segment of the population for the first time had become a reality but it also brought with it conformity in working patterns. An ambiguity many had a difficulty handling. There were also significant intellectual improvements. Secularisation, which had commenced already prior to industrialism, accelerated considerably and the churches' influence as a moral (and others) authority receded, and in some countries, through communist revolutions, entirely collapsed. Scientific rationalism, not only as part of the educational system and being the governing principle in industry, also formed

the worldview and cultural perspective for many where previously dominating art genres such as romanticism in literature and paintings, and *Art Nouveau* in architecture, which focused on mysticism and irrational aspects of life lost its allure. In art and life at large, rationality was conquering over irrationality, the predictable over the unpredictable, and machines were starting to win over humans in some domains at least, we could no longer outrun cars, and automated manufacturing produced quicker than even the most skilful artisan. People were both scared and fascinated by robots and the movies about Frankenstein's monster intrigued a whole generation. With the scientific approach, many contemporary humans believed that we were on the cusp of being able to completely explain our world. Few mysteries would be left as the rational scientific approach would conquer all remaining unknowns. This mindset had far-reaching, and for some unintended and unwelcomed consequences; monarchs' claim that their power had been bestowed to them from divine forces in this context appeared absurd, and many countries abandoned their absolute rulers, in favour for, often democratically elected, presidents. The perspective of socioeconomic class came, probably more than ever before, to be formed around economic wealth and the capacity to create such fortunes. And given that creativity and tenacity rather than owning vast areas of land now were the main ingredients for wealth building, there was a greater degree of social mobility between the previously so rigid class system, this as education became available, and made mandatory, for all citizens, not only the affluent. With the capacity for rational thinking as determinant, it was cognitive levels rather than pedigree that now came to decide the outcome of man, the gifted but previously destitute ones could embark on quite dramatic economic improvements versus the life only the previous generation had to endure. Economic and political power came to be more evenly distributed across society, albeit still far from achieving any kind equality amongst the citizens. Ironically for the communist ideology that deliberately sought to establish equality in a society free from economic classes, in practice they quickly evolved into absolute monarch-type of governmental

systems, whilst using drastically different labels for what in effect were close to identical functions and roles. The assumption of perpetual technical progress and with that economic progress was by many taken for granted; however, the First World War clearly highlighted that technological innovations could also produce sinister outcomes, as machine guns and mustard gas replaced swords, causing battlefield slaughters on an industrial scale that was previously unthought of and profoundly chocked many. It became evident to many that technology in itself was neither good nor evil, as it was still far from autonomous contraptions, but how it was used was still under the control of ourselves and they exacerbated our good or bad intentions.

In parallel with the high-paced technological innovation trajectory, we were starting to understand more about our inner selves, our mind and motivations. Psychology as an individual academic discipline was introduced, and theories from psychologists such as Sigmund Freud still influence our understanding of how the human psyche works with distinct conscious and unconscious parts, where in the latter uncanny forces in parts beyond our control influence our behaviour and perceptions. Then as today, these were however leisurely discounted as irrationality. In fiction, this remarkable two-sidedness was perhaps best (and most sensationally) depicted in the Scottish author Robert Louis Stevenson's *The Strange Case of Dr Jekyll and Mr Hyde*, an intriguing horror story that to this day continues to titillate readers. With the horrors and mass slaughter of the First World War in mind, few argued that mankind harboured a monster deep inside, perhaps as part of our unconscious, that could unleash and cause indescribable cruelties. At the time, Freud with his psychoanalysis method claimed that our *libido*, the sexual drive, could explain large parts of our behaviour to the point that we were in effect mere extensions of our sexual organs. But in the Victorian era leading up to the First World War, theories of this nature both disgusted and excited an outwardly, at least, prudish bourgeoisie, something which probably played a significant role to Freud's psychoanalysis becoming widely popular. A certain dichotomy came to reign, a rational demeanour

which was challenged by an unruly irrational unconscious part of our mind which we had difficulties bringing under control. The art communities of the time were very much aware of these, at times, conflicting forces, as they brought new interesting perspectives. The world could be viewed and represented in many different ways, both exclusively and inclusively of each other. Imagination and dreamy scenarios perhaps most eloquently presented by the Spanish painter Salvador Dali provided an artistic interpretation that still fascinates, it was labelled *surrealism*. Painters and sculptors started to deliberately distort proportions and perspectives as a method to describe the world differently; *cubism* is perhaps one of the most illustrious case in point. A staple in cubism was to purposely fragment a form or shape, in order to display and highlight its various aspects. The cubists experienced the world as disintegrated where numerous different trends were occurring simultaneously, which meant that traditional methods of sequentially outlining events no longer really applied, as the parallel unfolding of the world did not really fit such a constraining technique of artistic manifestation. Keeping several perspectives in mind became the preferred form of artistically depicting reality and providing a holistic and comprehensive understanding of a quickly changing world.[6,7]

As the 20th century progressed, science as an explanatory model of the world came to, in an overwhelming degree, dominate over the religious perspective. As science reigned over religion, it came with an important consequence of an existential nature. The basis of any religion is that it is grounded in a suite of unquestionable truths, dogmas, that come without any requirements of being backed by objectively ascertained evidence. It is in effect beliefs equated as absolute truths where the religious leaders "own" its interpretations, a power they guarded jealously with transgressors risking harsh punishments. Whilst religion over the centuries did change, as for instance the Protestant reformation testified to, it rested, and still does, on a suite of dogma that it argues stands above rational analysis. Scientific thinking reshaped that narrative completely, as the views on truth started to change from something absolute to something

relative, a transformation that is still ongoing. As science took charge, its "priests" were humbled by the swift advances that were made and were often careful in proclaiming they had knowledge that equated to absolute truths. A breakthrough that took science in entirely new directions was always lurking around the corner, probably best exemplified in how Albert Einstein in dramatical ways changed physics with his paradigm-shifting theories. And with the insight that there were so few absolute truths and what we knew always could be challenged and at any rate were likely to change over time, a certain level of openness, extending to humbleness, gave way for an acceptance that one ought to question all statements, even from experts, meaning that little could and should be taken for granted. An unquenchable curiosity and healthy scepticism were the preferred modus operandi in this inquisitive intellectual environment. This also influenced society at large and the way the general public viewed its leaders, as they were no longer seen as authoritatively omnipresent and knowledgeable.

By throwing old customs and habits in the historical dustbin and by opening up for a world set in constant change, across almost all imaginable areas, and even if there were a lot of optimism on how technology and innovation would improve people's lives, an underlying anxiety was lingering on what this meant for humans and how and where they should be positioned in all this.

The outbreak of the First World War was met enthusiastically by the intellectual elite and avant-garde art circles as a cleansing process to get rid of the petty bourgeois conventions and morals, seen as decadent and false which they thought suffocated the true human spirit. A war could help to build a new world that would free humans, it was perceived as "rebirth through death". One sought to reawake the *original human*, unspoilt by false pretensions, groomed and chiselled out through a survival of the fittest mentality that really only a war could provide. Armaments enhanced through technology were the conduits to accelerate this trend and quite literally get rid of the decadent and useless bread eaters. By returning to the original values, or at least what one thought those might be, it was the intellectual

elites' intention to find the source of life and by representing this through art, the inner uncorrupted nature of humans could be represented as an ideal to strive for, cleansed from all false decorative add-ons. The German philosopher Friedrich Nietzsche's writings on a degenerated human race, the envisaged demise of the Western culture, and the need for superhumans to rescue an otherwise dying world clearly displayed this sentiment, and Nietzsche regarded the pursuit of creating transformational artistic manifests as the only redeeming hope for salvation.[8,9]

However, this wish for death and destruction, a cleansing process of sorts, in order to rebuild proved to be a sinister *Faustian* pact that came with devastating consequences, as the war became high-tech, introducing machine guns, aeroplanes, submarines, and mustard gas, and the death tolls were catastrophic. A young generation of (male) Europeans that initially gladly had embraced war bled to death on the battlefields *en masse*.

From this historical perspective on how art has related to technology, let us explore some of the more influential art manifestos, and the noted differences they took depending on whether they were launched pre- or post-First World War, something which has come to be seen as a watershed moment. It is worthy to note how they chose to criticise and ponder over their contemporary world which much like ours was characterised by fast and transforming technological change and especially how they dealt with the man–machine encounter. Their insights are likely to have bearing for how we now must relate to our experience with artificial intelligence, that us willingly or not is taking place, and how art can act as a mediator to facilitate and, if possibly augment, this inevitable interaction. So, some of these insights and reflections provide a starting point for how we should artistically consider our own juxtaposition with artificial intelligence. We can benefit from hindsight and can judge our current time from a constrained narrative which of these, or parts thereof, proved most capable in providing a soothing and comforting perspective in this first amalgamation between man and machine.

## THE FUTURISTS

Futurism was presented through *The Futurist Manifesto* published by the Italian poet Filippo Tommaso Marinetti (1876–1944) in 1909. In hindsight, it appears as an almost eerily well-timed art manifesto with its unadulterated admiration of violence, given that the First World War was only a few years away. As its name alludes to, it was notably forward looking, rejecting the past, seeking a modernisation and renewal of Italy, as this at its onset was a largely Italian nationalist movement. However, unlike other nationalist movements, it rejected a glorious past, famous battles and heroes, and so on, but instead celebrated and promoted the exciting parts of industrialism, notably the new means of transportation, as a way to build a strong nation. It was about speed, daring youths, violence, cars, trains, aeroplanes, and machines, all lauded in poetic terms and brazenly depicted. The futurists sought to combine art and action and a worship of the machines, as it was through machines that humankind's basic needs could be met, allowing for humans to seek to perfect themselves through education, sports, and a healthy lifestyle that holistically and mechanically would bring both body and mind to perfection.[10]

The futurist's endorsement of violence highlighted the mood amongst quite a few influential groups of artists and intellectuals at the time. However, the futurist took this viewpoint to the extreme, considering machines more worthy to artistically represent than humans, which were to become their lead motif, and some of their members ranked machines before men full stop. They argued that this modern world with its faster pace would alter the human psyche as man and machine where eventually going to interconnect. But it was not only the motifs of art that had to be transformed, such as focusing on cars and aeroplanes and depictions of speed and force, instead of picturesque scenery and *stilleben*. All artistic endeavours had to be considered for change with a view of turning them anti-intellectual. As such, prose and poetry had to be cleansed from all type of inward-looking ponderings and long ivory-tower-like descriptions. They sought to make the literary language autonomous by liberating it, much like

they wanted to "cleanse" all other art forms from existing traditions and conventions. The futurists in a sense merely extended and mirrored what was happening in the industry where many of the previous handicraft practices and arrangements were discontinued and something new and something better from the perspective of automation, productivity and speed were introduced.[11]

Marinetti's futurist art manifesto serves as a good example of the format of the "typical" art manifesto, bar its many references of glorifying violence. Its composition follows a structure that highlights the agenda it seeks to promote and through what means, and what it is in contemporary society that it rejects.

## MANIFESTO OF FUTURISM (MANIFESTO DEL FUTURISMO)

- We want to sing the love of danger, the habit of energy and rashness.
- The essential elements of our poetry will be courage, audacity and revolt.
- Literature has up to now magnified pensive immobility, ecstasy and slumber. We want to exalt movements of aggression, feverish sleeplessness, the double march, the perilous leap, the slap and the blow with the fist.
- We declare that the splendor of the world has been enriched by a new beauty: the beauty of speed. A racing automobile with its bonnet adorned with great tubes like serpents with explosive breath ... a roaring motor car which seems to run on machine-gun fire, is more beautiful than the Victory of Samothrace.
- We want to sing the man at the wheel, the ideal axis of which crosses the earth, itself hurled along its orbit.
- The poet must spend himself with warmth, glamour and prodigality to increase the enthusiastic fervor of the primordial elements.
- Beauty exists only in struggle. There is no masterpiece that has not an aggressive character. Poetry must be a violent assault on the forces of the unknown, to force them to bow before man.

- We are on the extreme promontory of the centuries! What is the use of looking behind at the moment when we must open the mysterious shutters of the impossible? Time and Space died yesterday. We are already living in the absolute, since we have already created eternal, omnipresent speed.
- We want to glorify war – the only cure for the world – militarism, patriotism, the destructive gesture of the anarchists, the beautiful ideas which kill, and contempt for woman.
- We want to demolish museums and libraries, fight morality, feminism and all opportunist and utilitarian cowardice.
- We will sing of the great crowds agitated by work, pleasure and revolt; the multi-coloured and polyphonic surf of revolutions in modern capitals: the nocturnal vibration of the arsenals and the workshops beneath their violent electric moons: the gluttonous railway stations devouring smoking serpents; factories suspended from the clouds by the thread of their smoke; bridges with the leap of gymnasts flung across the diabolic cutlery of sunny rivers: adventurous steamers sniffing the horizon; great-breasted locomotives, puffing on the rails like enormous steel horses with long tubes for bridle, and the gliding flight of aeroplanes whose propeller sounds like the flapping of a flag and the applause of enthusiastic crowds.[12]

By the end of the First World War, celebrating violence was definitely no longer *en vogue*, and as many had gotten a more sombre view of the possibilities of technology, futurism receded into oblivion. However, its tenets and some of its more spectacular expressions of art were picked up by the aspiring fascist- and national-socialist movements and came to be incorporated both as political doctrine as well as in the style that they preferred to display themselves. Hence, the First World War provided a watershed moment in how artists viewed technology, the optimistic mode that had reigned prior to the Great War had changed to something much more dystopic, with a fear that technology often depicted as sinister robots could take a life of their own with less-than-altruistic intentions for the human race.

This dystopic sentiment of the time is probably best highlighted in Fritz Lang's epic movie *Metropolis*, where individuals are merely part of an anonymous human mass that are no more than easily replaceable parts in a big machinery, only evaluated through their production value, with little room for individuality. Later on, Charlie Chaplin's *Modern Life* presented this theme in a more humoristic style. It is through these lenses that we were observing a drastically changing world, where we for the first time had to figure out how to relate to machines, where they friend or foe or a bit of both?

## DADAISM AND SURREALISM

Art therefore took a different political direction beyond merely being ornamental, it was seen as a conduit to epitomise this ambivalence and act as a remedy seeking to heal the ills of society this confrontation was bringing with it.

Dadaism, an art genre that today is best remembered by the aforementioned Marcel Duchamp's porcelain urinal exhibited as an art objective, which like the genre's name, sums up the gist of it, a protest against bourgeois norms and morals which the dadaists accused of being an instigating factor to the First World War. Whatever the artist decided and produced would be art, and if everything was art, then subsequently nothing could be considered to be art, was the device they lived by, a sentiment that in parts has survived to this day. Provocations against the establishment, typically through displays of utter nonsense and absurdities often presented with a glimpse in the eye became a dadaist staple. The dadaists were anti-war, anti-nationalism, and anti-capitalist, and took an anarchist, almost an early prototype of the 1960s hippie movement, approach. It was in a sense a solely destructive movement, focusing on wanting to destroy Victorian norms that whilst having noted negative consequence, also had been of vital importance for the successful economic growth and innovative environment. It also ridiculed established artists who could have spent years on crafting a single painting or sculpture by comparing it with any everyday artifact or deliberately imbecile spectacles. In

the end, it was a protest movement that could offer little of value as a viable alternative, and subsequently its popularity waned as people grew tired of their antics. But it retained a lasting impression by delivering what can be said, thus far, to be the final nail in the coffin of the traditional aesthetic quality standards on art. The view on art never became the same, as an example, industrial design and art in parts integrated, where the beauty of a manufactured streamlined propeller by some was considered a perfected object of art.[13,14]

Surrealism took cues from dadaism but it expanded beyond merely being a protest movement, as it was influenced by, at the time, new and fascinating psychological theories of an unconscious part of the human mind and what it might contain. One of its leading representatives was the Spanish painter Salvador Dali (1904–1989), with his amazing motives of dreamlike scenarios that drew heavily on symbolism and mysticism, and they remain highly regarded from a qualitative perspective and is probably what most today would define as surrealism. The surrealists aspired by seeking to depict aspects of the unconscious, to represent a more holistic understanding of the human nature, which at times extended into spiritualist deliberations. And yes, Dali's paintings are indeed mesmerising, but beyond being eye candy what do you do with them, how do they elevate you beyond acknowledging that the unconscious probably harbours some mysterious contents? As psychology and neuroscience have only been able to marginally advance our knowledge about the unconscious since the last century, it was difficult for the surrealists to progress the art genre, and once the shock value was gone, it receded notably in popularity, and increasingly got interspersed and amalgamated with occultism and resorting towards fantasy, and, eventually, its steam was bound to fizzle out.[15,16]

## SOCIALIST REALISM AS A PROMOTER OF MAN AS A MACHINE

Realism, and in particular the Soviet version of it, is probably one of the most human hostile art genres of the 20th century. This as it

was in particular closely aligned and actively endorsing an author-itarian regime that engaged in a ruthless elimination of everything and everyone that did not fit its highly conformist and standard-ised view of the world. Essentially, it took the "cog in the wheel" metaphor to a new level: art as state-controlled propaganda would seek to form humans to fully adopt a machinelike behaviour through heavy-handed standardisation. Both fascism and socialism sought to eradicate all traits of individualism and create a mass man that was being groomed to desire and enforce a standardised political doc-trine. In the end, it came with disastrous consequences for anyone falling outside the norms of political conformity, where death camps operated on almost assembly line extermination.

Socialist realism is for the spectator a highly foreseeable and sterile art genre. The depicted humans seem to lack vivacity and the motifs appear as highly staged scenery, thus, despite its name, the artwork completely lacks realism but is rather an idealised depiction of what the regime wants their citizens to aspire to. It is glorifying certain values that are aligned with utopian goals, which was the creation of a worldly worker's paradise, or individuals sacrificing themselves for the greater good were favourite themes, and always arranged in simpleton stereotyped boilerplate setups. It was nothing but a carica-ture of robots camouflaged as humans, and the depictions strikingly revealed what the communist party expected from its underlings – robot-like conduct and obedience. The role model referred to was *The New Soviet Man*. Artworks were judged on how well they advanced the goals of the communist regime and on their educational qualities; hence attempts to produce creative expressions beyond party stand-ards were typically frowned upon and rejected, rendering the artist's career in jeopardy. It followed an orchestrated blueprint and pro-cess and therefore quickly became dull and uninspiring. Their dull-ness and highly predictable stereotypes inadvertently took farcical forms but any sense of irony was totally lost on the party diehards. An insight provocateurs picked upon and deliberately overexagger-ated these features through an approach known as *subversive affirmation*, which in effect cleverly transformed the artworks into critiques of

the regime. Reminiscences of socialist realism survive in authoritarian states with a heavy communist legacy, such as China and North Korea where they continue to reflect sterile and stereotypical depictions of state-approved human behaviour and utopian dreams of "heaven on earth" aspirations. It is however nowadays almost mostly viewed as parodic, yet that fails to register with pompous regime supporters, and because of these features rather than anything else sometimes hold collector's value.[17,18]

## THE SITUATIONISTS: AN ATTACK ON CONSUMERISM

The situationists were an art movement that commenced as a protest against the excessive consumerism which had reached frenzy levels post-Second World War, notably from the 1950s onwards. The movement was clearly left wing with its anti-capitalism rhetoric but its relationship with Marxism was quite complicated and far from straightforward. Rather, it promoted freedom with an anarchistic twist, some have labelled it as libertarian Marxism, as its interpretation of Marx writings was relaxed. It also took cues from previous anarchistic leaning art movements such as the provocative dadaism and psychologically inclined surrealism. It was overwhelmingly Eurocentric and Francophone, and one can in most of its writings and broadcasts recognise a general criticism against USA, rather than only on the account of it being the main source of consumer goods that flooded Europe and the lifestyle that that promoted, by creating superfluous demands people did not know they had but were conned into. The movement was formally referred to as *Situationist International*. Its main argument was that under capitalism, capital had become so completely pervasive, permeating through almost all aspects of a human's life, and that to remain sane, humans ought to revolt against what was one of capitalism's worst manifests: mind numbing, excessive consumerism. The dominance of capital was in particular notable through a consumer fetishism phenomena that had created a *society of the spectacle* in which man now was merely a

spectator with little ability to influence but passively had to soak up all lowbrow culture that overwhelmed society with its only purpose to increase consumption. They were critical against previous art movements that whilst they rightly had criticised capitalism, they had not been able to make any material changes to the system they were against. The situationists argued that previous art manifestos had cleverly been neutralised by the mechanisms of capitalism through basically appropriating and embracing their objects of art, in effect reducing its subversive intentions and turning them into mere consumer products, that in the end mostly were admired for whatever commercial value they might hold. In the situationist manifesto, one of its founders, the French philosopher Guy Debord (1931–1994), described how the establishment basically hijacked radical ideas that confronted the *status quo* by deliberately seeking to trivialise and sterilise them, and then incorporate them back into mainstream culture, where they were viewed as whimsical trends that could be commercially exploited. Their potentially contentious political content had effectively been subdued. They had just become another part of the consumer society, void of symbolic meaning, another fad and gimmick soon to be replaced by something else, some similar balderdash. The realisation of this process, which the situationists labelled *récuperation*, had drastic consequences for their view on art. The Situationist International argued that the true purpose of an art movement was not the creation of experimental and thought-provoking art objects but to use it as a means to produce revolutionary awareness amongst the population. They expelled all artists from the Situationist International and proclaimed that from now on art should be realised in true revolutionary spirit rather than represented through traditional manifestations. Anti-art became the preferred modus operandi with a view of creating subversive and critical effects against society. It was in sorts the creation of artistic acts of terrorism, albeit non-violent, and these should be performed so that its true intent was promoted covertly, namely that of instilling a revolutionary sentiment and an awakening that would realise the detrimental effects of consumerism, thereby rejecting it. This

was the situationist's preferred method to counter *récuperation* and it was called *détournement*, the construction of situations, moments of life deliberately arranged for the purpose of reawakening and pursuing authentic, instead of artificially induced, desires, thereby experiencing the feeling of life and adventure, and aiming for the liberation of everyday life. As the French term alludes, it consisted in turning expressions of the capitalist system against itself, like reversing slogans and logos against the advertisers or the political order.[19,20,21]

They borrowed Marxist concepts such as *alienation, false consciousness,* and *commodity fetishism,* which were frequently used to describe the predicaments that humans had to succumb to having to survive in this society of the spectacle. It was apt as these were phenomena that only had exacerbated and expanded since the early capitalism that Marx had analysed. This era of consumerism had come to implicate a lot more aspects of human life than ever before, and it had started to eclipse society at large. The spectacle which the situationists raged against was nothing but extensive advertising of consumer goods through different formats. These were triggering artificial desires for goods and services that we did not really need, a consumer fetish of sorts, this by manipulating and transforming the authenticity of life into tradeable commodities on constant display through the spectacles. The spectacles brought everything down to a simple narrative, attempting to reduce the complexities and intricacies of the world down to a question of consumption through targeting our lower instincts seeking to trigger the desired emotional response. Humans were being trapped through what the Marxists referred to as false consciousness, where big corporations, endorsed by and paid for politicians, concealed and sometimes wilfully misled the population, notably the working class, on what it is that truly matters in life. The purpose of these spectacles was to pacify the masses, refraining them from asking crucial questions, making demands and ultimately protest and revolt against the state of affairs that mistreated them. By these pacifying techniques, which Marx so eloquently had described already a century earlier, and focusing the hoi polloi's attention on

sheer nonsense entertainment, news, and the likes, dissent could be quelled and not allowed to take the form of a protest movement. Situationist theory viewed the instigation of these temporary moments of awakenings, *détournements*, as their main artistic tool for the liberation of everyday life. It was a method of negating the pervasive alienation that accompanied the consumer-focused spectacles, mainly manifested through advertisements, two-bit entertainment, and tabloid mass media.[22]

In the analysis by the situationists of their contemporary society, one can sense a hostility towards the new technologies that were being introduce as this was in the early days of the information society. Whilst the many improvements of life, not only from the economic perspective, were undeniable, they weighed these benefits against the social dysfunction and degradation of life in general that it simultaneously inflicted. What this society of spectacles in essence came down to was the manifestation of social relations through the consumption of commodities, or the passive, almost non-stop, watching of crude entertainment. The detrimental psychological effects this had on the human soul would according to the situationists cause far-reaching damage to the quality of human life for individuals and society alike. But their manifesto was notably silent on how to positively embrace technology, to the benefit of the individual that would provide them an edge *vis-à-vis* big corporations and big government.[23,24]

## WHAT ARE THE IMPRESSIONS OF THE ART MANIFESTOS ENCOUNTERING THIS FIRST GENERATION OF THE MAN-MACHINE CONNECTION?

Taking the starting point from this first uneasy juxtaposition between man and machine gives an insight how the illustrious artisans of the day sought to mend ways and present art as the forum to overcome these challenges. Prior to the First World War, technology was mostly viewed uncritical, although few took it to the extreme of the futurists; however, after the war the mood had become considerably

sombre, a message that the dadaists and surrealists in provocative ways sought to convey. Naïve and childish, yes, but a perfectly explainable reaction to a mindless war where a large contingent of the best educated generation of Europeans was wiped out in a matter of a few years. Apart from being protest movements against the sinister usage of technology, highlighted through artistical mischievousness, they left little in terms of constructive legacy other than some amusing trinkets.

In authoritarian settings, the view of humanity, as promoted by the futurists and largely adopted by fascism and national socialism in the 1920s and 1930s, and socialist realism which resided on the other end of the political spectra, shared commonalities, humans had to conform and become more machine like, and were most likely on the long-term trajectory of eventually being succumbed by machines, as deviating individual traits had to be rooted out and terminated.

The situationist rightly drew its ire on the emphasis of consumption made possible by technological improvements throughout the production and distribution chains reaching new heights after the Second World War, pointing out how it was fretting our souls through feeble spectacles. They were highly concerned that we were entering a zombielike stage where we had lost our humanness, and it is not like the consumer frenzy has receded since the 1960s with artificial intelligence in an increasingly degree embedding itself inside our minds, seeking to alter our preferences and narratives in accordance with the wishes of the highest bidder gaining access to the control of the best algorithms. But they had little to say on how we could tame the technological beast to our advantage in ways that would empower the individual.

Equipped with the insights of humankind's first encounter with machines that mainly challenged and simultaneously augmented our bodily capacity, artificial intelligence is similarly ambivalent: both parallel conquest and cooperation with our minds. How should we respond this time, and can an artistic articulation beneficially alleviate this inevitable integration?

# NOTES

1  Gaut, Berys. The Cluster Account of Art Defended (British Journal of Aesthetics, 45, 2005). pp. 273–288.

2  Danchev, Alex. Modern Classics 100 Artists' Manifestos: From The Futurists To The Stuckists (Penguin Classic, 2011).

3  Caws, Mary Ann. Manifesto: A Century of Isms (University of Nebraska Press, First edition, 2000).

4  Lyon, Janet. Manifestoes: Provocations of the Modern (Cornell University Press, First edition, 1999).

5  Antliff, Mark & Leighten, Patricia Dee. Cubism and Culture (London, United Kingdom: Thames & Hudson, 2001).

6  Ronald W. Clark. Freud: The Man and the Cause (Random House Inc, First edition, 1980).

7  Mannoni, Octave. Freud: The Theory of the Unconscious (London, United Kingdom, Verso, 2015, original 1971).

8  Eksteins, Modris. Rites of Spring (Boston, MA: First Mariner Books edition, 2000, original 1989).

9  Kaufmann, Walter. Nietzsche: Philosopher, Psychologist, Antichrist (Princeton University Press, 1974).

10  Marinetti, Filippo Tommaso. Critical Writings (edited by Günter Berghaus, New York: Farrar, Straus, and Giroux, 2006, original 1911).

11  Marinetti, Filippo Tommaso. Technical manifesto of futurist literature (original 1912) In White, John J. Literary Futurism: Aspects of the First Avant Garde (Oxford, UK: Clarendon Press, 1990).

12  Marinetti, Filippo Tommaso. Manifesto of futurism (original 1909) In Lynton, Norbert. Futurism (Nikos Stangos, editor. Concepts of Modern Art: From Fauvism to Postmodernism (3rd edition. London, UK: Thames & Hudson, 1994)).

13  Richter, Hans. Dada: Art and Anti-art (New York and Toronto: Oxford University Press, 1965).

14  Bergius, Hanne. Dada Triumphs! Dada Berlin, 1917–1923. Artistry of Polarities. Montages – Metamechanics – Manifestations (Translated by Brigitte Pichon. Vol. V. of the ten editions of Crisis and the Arts: the History of Dada, edited by Stephen Foster, New Haven, Connecticut: Thomson/Gale, 2003).

15  Alexandrian, Sarane. Surrealist Art (London, United Kingdom: Thames & Hudson, 1970).

16 Breton, André. *What is Surrealism?: Selected Writings of André Breton* (New York: Pathfinder Press, Rep edition, 1978).

17 Prokhorov, Gleb. *Art under Socialist Realism: Soviet Painting, 1930–1950* (East Roseville, NSW, Australia: Craftsman House; G + B Arts International, 1995).

18 Golomstock, Igor. *Totalitarian Art in the Soviet Union, the Third Reich, Fascist Italy and the People's Republic of China* (Harper Collins, 1990).

19 Debord, Guy. *Report on the Construction of Situations. Situationist International Anthology* (Berkeley, California: Bureau of Public Secrets, translated by Ken Knabb, 2006, original 1957).

20 Debord, Guy. The Society of the Spectacle (*Black & Red*, 1967).

21 Ford, Simon. *The Situationist International: A User's Guide* (London, UK: Black Dog, 2004).

22 Debord, Guy. Preliminary Problems in Constructing a Situation (Internationale Situationniste No. 1. Paris, June 1958. Translated by Ken Knabb).

23 Plant, Sadie. *The Most Radical Gesture* (New York: Routledge, 1992).

24 Debord, Guy. Definitions (Internationale Situationniste No. 1. Paris, June 1958. Translated by Ken Knabb).

# 2

---

# THE HUMAN EDGE: WHY OUR WEAKNESS MIGHT BE OUR STRENGTH IN THE BATTLE AGAINST MACHINES

> The devaluation of the world of men is in direct proportion to the increasing value of the world of things.
>
> Karl Marx, German philosopher *et al* (1818–1883) Economic and Philosophical Manuscripts of 1844. Estranged Labour

As artificial intelligence through its many manifests now enters everyday life to the extent that it might be called a paradigm shift, even a revolution, what does that mean for us? To start with, it is important to understand what artificial intelligence really is and what its developers have intended for it to do.

Artificial intelligence is, much as intelligence itself, hard to pin down as a phenomena, however, from its origin in the 1950s, the objective was that it should aspire to imitate the human mind with its problem-solving abilities that can be applied both to everyday and abstract situations. This referred to a concept known as "General Artificial Intelligence"; however, it has proven easier said than done, and now decades later the challenge still remains to the point that some question whether it is actually a viable quest at all. Human intelligence has so far proven to be far too versatile and too flexible to be

captured in computer code. Hence, artificial intelligence has mostly been applied on more narrow aspects of human behaviour, such as where an algorithm can help to understand speech or identify objects or a person in an image or video. Therefore, the term "artificial intelligence" remains somewhat elusive, and currently covers a broad range of items such as straightforward statistical regression techniques to the original ambition of fully replicating the human mind. So, artificial intelligence is really not intelligence in any autonomous sense but rather a collation of algorithms designed to recognise patterns and based on these make inferences, typically following matrices and vectors. Hence, it cannot, in that sense, create art, but it can create patterns that an audience will likely perceive as art, it is just that the creation does not relate to a concept or idea if not initiated by the programmer instructing it.

It is with such insights that the intersections where artificial intelligence merges with humans must be understood and considered as complex events. It goes above and beyond just the technology and therefore should be described from several perspectives to be holistically comprehended, technology obviously but also psychology, sociology, linguistics, and philosophy amongst others. This technological revolution is forcing the way that we understand the world and ourselves to be reconsidered and even confronted. Much as we humans, each and every one of us can be formulated as a DNA code, can at the abstract level be recreated, can we, or our behavioural conduct, perhaps also soon be defined through a string of algorithmic patterns? In short, the boundary between humans and machine is becoming increasingly blurred, but will it eventually altogether cease to exist? What then remains of humanity and human values? Are we humans, or at least some of us, becoming superfluous? There will be infliction points that are likely to trigger contentious reactions as a myriad of data where our connected existence can be largely digitised and formulated through models. Within these confinements, machines can become so humanlike, in terms of cognitive capabilities but also able to capture those peculiar features, idiosyncrasies, and irrationalities of sorts, which on a few rare occasions manifest as

amazing creative capacities that so far have been so hard to translate into computer code.

The increased use of and reliance on technology has of course greatly eased the physical burden of everyday activities, where also many of our interactions with other humans has moved to a raft of communication applications and tools. All these technical contraptions and features, now augmented through a virtual realm and artificial intelligence models, are in a sense even alienating us further from the physical meeting with fellow humans, we are becoming "lonely crowds" sitting isolated one by one yet gathering in digital communities. What concerned the situationists already in the 1960s would, with the advent and evolvement of internet and the various social media platforms, scare them considerably more today, where all our activities, expressions of opinions, moods and sentiments, and attempts to interact with other humans in one way or another are being tracked and monetised. Our behaviour can increasingly be defined through patterns picked up by algorithms. And as many have come to realise, whilst participating on these social media platforms appears to be "free", the data traces we leave behind have become a valuable commodity as they are being commercialised into an asset, although a fickle one, where the perceived economic value quickly declines and eventually becomes obsolete as the products, services, and processes have themselves become obsolete. In a sense, capitalism is commoditising us, cannibalising its own values to the very core of human behaviour and purchasing patterns.

This is an entirely new world to the point that our current language cannot really fully convey all these nouvelle phenomena, and we know from language philosophy that the way we label concepts and objects are not independently detached from reality but au contraire intertwined and forms not only how we view the world but also how we act and react in it. Abstractions of phenomena in our language thus in effect become a part of reality, and this in particular increasingly so in the blurred twilight zone between humans and machine, where the machines can be seen as different types of prothesis, extending and enhancing our bodies and minds, in stark

contrast to earlier generations' perspective of "us and them" with robots being distinctly separate agents. Artificial intelligences will be everywhere and part of everything and possibly everyone, ubiquitous and pervasive and we describe what is now unfolding mainly through spatial metaphors as our language is still exploring a better vocabulary to capture these phenomena. But will we know when it is that artificial intelligence actually equates the human mind? It is a question that requires both philosophical and psychological perspectives. Human reasoning rests on a set of experiences which are formed through our cognitive abilities and the culture we are exposed to, resulting in a unique identity. Those experiences are dependent on interactions with other humans, which are accumulated and elevated to cultural and societal levels. The cognitive ability is an important, but not entirely decisive, component of our reasoning ability; a person with an IQ of 80 is expected to behave and act differently than a person with an IQ of 120, as the latter typically will make more "rational" decisions, even on identical experiences. However, regardless of cognitive ability, the quality of our reasoning is curtailed by reigning discourses, and as a rule the narrower the discourse, the less rational we will be. Also, the perceptions from the world around us require internal interpretations, a lot of them are not that clear cut; hence humans need to be able to handle and respond to events that contain:

- ambiguity
- incomplete information
- incorrect information
- multiple points of view, including opinions and hypotheses

Hence, to accommodate events with a (high) degree of uncertainty, humans must be capable of understanding utterances, reflect upon them and judge them vis-à-vis our discourses, formulating and revising plans, generating emotional appraisals, and choosing actions despite the assorted imperfections with a view of meeting set goals. Typically, one seeks reference points from memory on how to act

and reason in every situation, where even minor resemblances can provide cues on behavioural patterns. As such we are bound to make occasional mistakes, this because we often use heuristics or approximations based on previous experiences, or we simply follow the path of doing like everyone else, herding behaviour, even if we are aware that it will contradict our goals.

Engaging with other humans becomes an exercise to correctly interpret a counterpart's opinions and questions, which calls for an ability to understand their specific discourse, or belief system, whether that be of a cultural, political, or religious nature, or usually a combination thereof. As discourses act as blinders on reality, in effect transforming it to a *social reality* where reasoning is often confined to the perceptions that filters through its boundaries, ignoring a diverging actual reality outside its dogmatic tenets. This is what artists pick up on and it is why genres have been waxing and waning over the centuries. This means that even when arriving at conclusions following the correct deductive steps, for a person operating on a differing discourse, our inference is seen as an aberration, even bordering to self-deception and outright irrationality. The insight, whether acknowledged or not, that there is a discrepancy between reality and social reality triggers a highly interesting psychological effect, *cognitive dissonance*, and unless one is aware of the nature of the existing discourse, human behaviour under its influence becomes irrational and unpredictable. But because the social pressure is so strong to comply with the reigning discourse, few of us are able to see beyond it; however, the perceptive artist manages to capture this phenomena and depict it, exciting the contemporary audience as they can articulate something most people might sense but lack vocabulary to express. Psychological insights as previously described often play a great role in deciding the popularity of art.

Hence, an integral part of most human communication is *miscommunication*, something that becomes evident when analysing a transcription from an interview or an exchange on social media. Sometimes these disconnects are due to incompatible discourses, or

sometimes the cognitive difference between the counterparts is too deep to overcome. However, we humans often expect this to happen and at times adjust accordingly, so when encountering an individual with a lower cognitive level, such as a young child, our language and reasoning simplifies, this also happens when conversing with someone outside our area of expertise; we drop jargon and refrain from including the finer aspects of our knowledge, or most of the time we simply just drop that conversation altogether when realising that nothing meaningful is expected to come out of it. This happens as much in real life as on various social media.

Then there is another matter that defines human reasoning, which usually is of great importance to any artist, fantasy and imagination, which is something we know from psychology that most humans tend interchangeably the to mix with reality, often becoming a blurred twilight zone of ambiguities, typically providing rich pickings for the perceptive artist. Fantasies are often interlinked with our goals and ambitions, where highly wishful thinking is applied on real-life situations where probabilities of a preferred outcome occurring is miniscule and yet chosen, this despite an accurate insight of the actual circumstances, leading to irrational behaviour, such as suddenly feeling lucky and deciding to play the lottery.

But unfortunately for the designers of artificial intelligence algorithms, the complexities of human reasoning do not end here, as the psychoanalysts under Freud *et al* had discovered, the human mind (an abstract notion of the source of our thought patterns) consists of a conscious and an unconscious part with separate logic structures and these absorb reality in diverging chunks, with the former truncated through narratives that constraints our view of reality through more or less rigid assumptions and the latter able to amass broader perceptions of reality. These are held together and controlled through a governing mechanism. They interact in accordance with a protocol that can be perceived as seemingly irrational but it is far from it; rather, it follows a diverging schema aligned to attain goal maximation, and we both have conscious and unconscious goals. This brings an additional element of irrationality in human reasoning that is difficult for

a machine to replicate, and is often the source for artistic inspiration.
So, broadly, five components define our capacity to reason:

1. our cognitive level (which we can do little to influence)
2. the narrative, or belief system, that defines us and the culture
   we live in (which fluctuates over time and place and through
   boundaries limits our perspectives of reality)
3. the perceptions we are exposed to, forming a memory base of
   knowledge and experiences, past and present from which we
   draw inferences of which many are only registered unconsciously
4. our blend between reality and fantasy
5. our goals which exist on both sides of the level of awareness and
   provide a perspective of the future

With the wide variety of what human reasoning really is, it is some-
what hard to ascertain how close an artificial intelligence algorithm
is to human reasoning. One, at least theoretical, starting point could
be the mythical Turing Test. It has for almost 70 years been seen as the
litmus test to determine whether machines could think as humans,
but how valid is it really? What is it that the test actually aspires to
measure, and what if humans fail it, does that mean that they are
deemed void of human reasoning?

The Turing Test was developed by the English mathematician Alan
Turing in 1950 as a means to assess whether machines had the abil-
ity to display humanlike intelligent behaviour to the point that they
no longer could be distinguished from humans. Turing proposed
that the test should be designed so that a human evaluator would
judge text-only conversations between a human and a machine from
a natural language perspective, being aware that one of the partici-
pants indeed could be a machine.[1]

Typically, the tester tries to snare the assumed machine with pleth-
ora of cognitively related questions, which could be of an arithme-
tic nature, such as *what is 8 × 8?* that an intelligent human with ease
should be able to answer, blended with inhumanly difficult ques-
tions that also an intelligent human should fail, as well as, questions

of a more philosophical nature, such as, *if you close your eyes, does that mean that the car in front of you no longer exists?* Whilst the answer to this question might seem obvious, in fact most people, due to a common psychological phenomena, occasionally do choose to overlook the obvious, pretending it is not there, or the reverse, assuming things that are not a feature, which witness psychologists are very aware of, as perceptions becomes subordinate to rational assumptions. The machine would pass the test, if the evaluators were not able to identify it as a machine through this battery of various questions aiming at seeking out the characteristics of human reasoning. Given that level of natural language is a screening criteria, the decisive qualifying quality is more about the machine's ability to mimic how a human would communicate and reason rather than giving correct answers to all queries.

And whilst the Turing Test has been criticised from a philosophical perspective, it remains a standard test to determine whether applications can assume humanlike reasoning. But the sticking point is that the both the qualitative and quantitative definitions of human reasoning remain unclear, Turing himself was silent on that point, and would ultimately depend on the individual tester. Then there also is the much less discussed other side of the coin: what about humans failing the test, being singled out as robots in the test? Would that mean that they are bereft of human reasoning? This has been something of a blind spot in the exclusively one-sided Turing Test, but carries a significant impact as the assumption has always been that whilst machines could be caught out as just being machines, humans would always pass the test and never assumed to be machines. If the test can identify an actual human lacking the ability to reason like a human, well, how can we then know for sure that a machine is not reasoning like a human?

There are two main reasons to why machine generating human reasoning has proven so hard, the first is philosophical, and has been described in the previous sections, namely the wide variation of human reasoning makes it hard to precisely pin down, and we have to resort to approximations. The other reason is psychological,

a failure to understand the workings of the human mind, and in extension to properly model it. There obviously are software that are more intelligent in performing a specific task, or rather better, than humans in certain aspects, including the imitation of paintings; however, these are far from able to comprehend and reason like a human. This including our seemingly irrational thought patterns which often drives decision-making, also on a collective basis. To this, humans have generalised intelligence, and as noted to a degree depending on the individual, sometimes loosely defined as *common sense reasoning* and it poses another so far unsurmountable difficulty to sufficiently train algorithms to find repetitive patterns in data to learn, adapt, and respond to new situations, in a human rather than necessary accurate manner.

This insight succinctly highlights the key point, namely that the modelling of human reasoning needs to mimic the imperfections, which is what makes us precisely human and, in extension and for the purpose of this book, how to understand and produce art. Why that has not yet been acknowledged, perhaps not at all, by the artificial intelligence community likely comes down to its engineering approach, developing its algorithms through rationality alone, and hence implicitly considering the world solely through the spectacles of a solely rational mind. But psychology, and notably psychoanalysis, takes a particular interest in deviations, extending to the abnormal, exploring the background to human ambiguities and irrationality. To design and develop machine-generated human thought patterns, these two views need to find a common ground, perhaps starting through asking the question: can we have a rational understanding of the irrational, and at the core stands how it manifests in art?

For instance, when a situation fails to materialise as one would logically expect it to, we often come to brush it off as an act of irrationality, somehow being bereft of the appropriate deductive inference, and more often than not we leave it at that. The term irrationality is typically interchangeable with vocabulary such as illogic, primitive, unintelligible, mystical, or even crazy. The many labels highlight the

vague understanding of what irrationality really is, often it is simply given a negative definition, a contrast to what is rational. But a negative definition is hardly a satisfying one in truly understanding the phenomena, and irrationality is often glossed over in academia, assuming *the rational man hypothesis*, belonging to the category residual error. And it is often in this residual error that creativity resides.

It has long been a matter of debate on how rational human behaviour really is, the so-called *Great Rationality Debate*, a topic yet to be concluded, and irrationality has been studied, albeit sporadic, from the psychological perspective, extending into philosophy and religion, and more recently in cognitive sciences. There is ample evidence that in both profane and sacrosanct situations, human reasoning and subsequently the ensuing acts must be categorised as irrational, and artists often make a point of picking up on it, making it a central theme.[2]

The standard explanations for these anomalies, and irrationality in general, are that they are due to either cognitive constraints or temporary emotional duress which triggers a distorted and panic-ridden view of the world. Other explanations of irrational behaviour include:

- There is a deviation between an individual's actual preferences and what they believe them to be, with the latter often opiniated by reigning fads and trends that override, provisionally at least, these preferences being exacerbated through conforming and herding tendencies.
- There is a tendency to stick to the preferences one usually adheres to in normal settings in abnormal conditions, often through forces of habit
- There is a tendency to resort to generalisations and stereotypical thinking.
- In situations of mental duress, even extending to fear and panic, these strong emotions with a *fight-or-flight* mentality take control over one's rational decision-making process. There is a recognition of such acts, typically labelled *temporary insanity* or *diminished capacity*, terms accepted by most legal systems, covering cases where phases of irrationality are considered triggered through stress or trauma.

- Due to poor cognitive ability and/or dogmatic beliefs, decisions are being made that rest on whimsical, even ridiculous assumptions, but are viewed as "hard" facts, believing that they are acting in a rational capacity.
- Incorporating perceptions residing in the unconscious part of the mind as the basis for an informed decision, whilst outwardly it appears to be irrational, is in fact rational given a broader body of perception being taken into account.[3,4]

Perceptions and information considered as basis for decision-making obviously will influence the level of rationality, as such if the access to certain information is constrained, whilst deploying rules of inference correctly, observing it from a holistic perspective, it can constitute an irrational outcome as critical pieces of information were not incorporated. Such situations often occur in complex situations where rules-of-thumb, or heuristics, come to serve as tools in trying to get a grip of a problem in a timely manner. This is sometimes referred to as *bounded rationality* and includes situations where decision-makers will have to make do with satisfying rather than optimal decisions, as assessing every possible outcome is either too time consuming or simply too complex. The originator of the term, the American economist Herbert A. Simon (1916–2001), argued that humans in their behaviour are only partly rational and many of their actions, individually as well as collectively, must be considered irrational due to lack of the full suite of information.[5]

Also, presumptuous stereotypes can trigger irrational decisions, something which the American psychologist Dan Ariely highlighted in his 2008 book *Predictably Irrational: The Hidden Forces That Shape Our Decisions*. According to Ariely, stereotyping holds a strong propensity to influence perceptions, interpreting them due to pre-conceived opinions and expectations, and these can be both of negative or positive characteristics. But as stereotypes often are of an unconscious nature, it is difficult to be aware of their influencing power.[6]

So, the view among cognitive psychologists is that they do recognise recurring irrational patterns caused by heuristics or biases,

such as stereotypes, or simply information limitations in situations of stress due to its complexity or lack of time to do a comprehensive analysis. In essence, the view is that irrationality occurs where and when the rational cognitive process is temporarily put out of play, and therefore is treated and modelled as an anomaly.

There are, however, good reasons to believe that there is more to irrationality than merely being an anomaly, that some aspects of irrationality deliberately prompt to override rationality in the aspiration of cultivating elevated knowledge. In the broad definition of irrationality, this would be its most valuable facet and as irrationality transcends all human endeavours, attempting to seek out such manifests becomes a worthwhile excursion in the quest for common denominators, this to ascertain whether irrationality can be caused by premeditated goal-seeking thought patterns. Of particular interest are supernatural experiences, such as revelations, which presume access to higher levels of knowledge, and by their proponents are declared as being instigated through divine interventions. Also, art, which has its origin from religious devotion, shares this aspect of irrationality, as often the greatest works of famous artists, composers, and poets manage to capture inexplicable mystical elements that somehow resonate with their audience and become a defining point of what makes their artworks timeless. In these instances, the irrational components break with the explainable, somehow relaxing the deductive steps between cause and effect as seen by its contemporary interpreters. And it exemplifies a level of transgression against what is *comme il faut*, the reigning thought conventions, and it risks challenging the norms that form the edifice of the reigning civic society; possibly that explains its alluring effect to many with an innovative and rebellious streak. But whilst it breaks with accustomed convention, it often contains aesthetic features that harmonise thought patterns, and manage to, through the amalgamation of rational and irrational thoughts, improve human acumen and insights. The interesting question is whether there are means to model and replicate such harmonisation of apparently diverging thought patterns, and could it facilitate the creative process to the

degree of our immortal artists. The answer is yes, and another title in this series, *AI for Creativity*, provides a computational creativity blueprint for synchronising these thought processes and, what more is, to develop a computable model.[7,8,9,10]

Also, in mathematics has irrationality been considered, as contrasting the rational which is seen as something that can be exactly determined, whereas irrational numbers are infinite as they must be expressed with a never-ending string of decimals. As such, the irrational transcends a full comprehension and is boundless rather than finite in nature. The Austrian mathematician Kurt Gödel (1906–1978) in 1931 proved that *any* mathematical axiom contains irrational factors that cannot be eliminated, highlighted through *Gödel's Incompleteness Theorems*. Some physicists, notably the Dane Niels Bohr (1885–1962) and the Austrian Wolfgang Pauli (1900–1958), deployed the concept of irrationality as a phenomena not capable of further reduction, and Pauli argued it was one of the main reason for humanity's lopsided view of the world, the lack of understanding of the irrational. In essence, irrational is something beyond reason but not necessarily something contrary to reason, being beyond the limits of rational thought, and therefore comes to represent the boundary of our knowledge.[11,12]

The French mathematician Blaise Pascal (1623–1662) was once quoted saying, "The heart has its reasons which reason does not know", meaning the irrational as operating on a set of rules of its own, ideas which over time were rendered into a philosophical school, *sensualism*, highlighting the influence of the human senses on behaviour. The German philosopher Arthur Schopenhauer (1788–1860), further expanding on this concept, wrote extensively on the existence of a metaphysical will. This will, which can be loosely understood as desires and urges, in essence a survival instinct of sorts, was according to Schopenhauer irrational in nature, in that humans followed its direction in ways that invariably could not be described as rational, and thus governed aspects of humankind's existence. From that perspective, humans could not fully comprehend this metaphysical will as it operated below the level of awareness.[13]

*Irrationalism* was a philosophical movement that appeared in the late 19th century and remained *en vogue* into the early 20th century, it took aim at purposefully expanding beyond the rational as a means to enhance and enrich the human experience by aspiring to achieve a fuller dimension of life. Irrationalism came to put emphasis on trusting one's emotions and instincts, especially if they belied reason. It contravened and rebelled against the strong focus on science with its rationalism and reductionism that dominated the time epoch. The German philosopher Ludwig Klages (1872–1956) went so far as to claim that irrational outbursts are an intrinsic part of human nature and therefore one should act on them in order to eliminate nonessential aspects of life. The gist of irrationalism is that humankind's rational models of the world are not capable to fully explain it, and in the cracks irrational phenomena appears. It is here important to distinguish between irrational versus non-rational. Irrational in this sense is something that evades what can be fathomed through the rules of inference rather than something that violates it. From the religious context, the irrational takes the shape of paradox or mystery, and with the insight to these comes an elevation to higher spiritual wisdom where these apparent contradictions somehow harmonises, something which religiously inspired painters captured, typically a popular motif during the Middle Ages.[14]

Over time and leading up to current times, irrationalism has indirectly gained recognition as the number of diehards believing in rationality and reductionism have lost ground. Amongst most academics and in the scientific community there is a widespread recognition of the limitations with current models which reduces their explanatory power. This view has extended to the very extreme postmodernist theories where nothing can no longer be accepted as certain and everything must be regarded as relative rather than absolute.[15]

Many have been reflecting over the philosophical aspects, often under the label of posthumanism extending to cyborgs, a sort of part human part robot, and what is set to unfold with both our bodies and minds as they can be translated as data patterns and

information, and in particular when the boundaries between our minds and artificial intelligence becomes blurred. Thus, the post-human idea of a person existing in a state beyond being human will make them exempt from the always overhanging question of mortality. How we increasingly will be able to download one's own consciousness or mind into a software will to an extent highlight it. Many of our most important decisions in life do rest on the insight and consideration of life and death, albeit only occasionally so frankly articulated. But with that motivation omitted, and the insight that time and resources are limited with the occasionally stark choices having to be made, all underpinned by strong instinctual forces, many of the decision humans make with that backdrop can be viewed in an altogether new light and might actually never have been made. Reinforcing the creative process are also the emotions that accompany the mortal insight, for instance how many of the masterpieces of art have not been produced with love in mind or some higher spiritual aspiration? With the fervour and sparks of creativity these forces do produce, as testified by many artists' own accounts, they are major contributors in artworks taking shape, not unusually taking the artist into previously unthought-of directions. The quest for survival, both in its physical and mental dimensions, comes into play, the phrase "necessity is the mother of invention" and the acknowledgement of some degree of interconnectivity between creativity and mental ailments often produced out of a misery and other emotions might not currently be possible for a computer code to fully fathom and adjust to. There is something that goes beyond rationality to find these surprising but previously unconnected dots that make sense and are value adding. This important insight is not the creative power such emotions might release but rather the perspective of seeing the world from a radically new perspective in the desperation of breaking the rut; this will trigger perceived irrational thoughts and doing things at times radically differently. And these oddities, even if they at times appear absurd, might be the last human asset in the competition with machines. What is preserved of a human through a collation of algorithms

will likely only be an encyclopaedia of the information and perceptions we have gathered. At best, it will then carry an uncanny resemblance of ourselves but lacking the sometime eerie connections between certain aspects of memories tied together either through an unlikely chain of events or some miniscule yet import common denominator.[16,17]

## UNDERSTANDING WHAT ARTIFICIAL INTELLIGENCE IS UP AGAINST

Our innovative and creative capabilities rest to a large degree on imagination, often characterised by seemingly irrational patterns making very little sense until they do, and through *eureka* types moments a new artistic (or other) idea can be conceived and sometimes with dramatic effects leading to paradigm shifts. However, even the most talented artists are at pain to explain and rationalise this process, and perhaps the ancient Greeks in the Classical Era expressed it best when attributing these moments of illumination to divine benevolence. Whilst they used an arcane language to explain this phenomena, we have currently not come that much further in explaining the underlying mechanism, and until we can do so comprehensively, it will remain a significant challenge for any data scientist to translate it into code.

## NOTES

1  Turing, Alan. Computing Machinery and Intelligence (*Mind - A Quarterly Review of Philosophy and Psychology*, LIX(236). October, 1950).

2  Stein, Edward. *Without Good Reason: The Rationality Debate in Philosophy and Cognitive Science* (Oxford, UK: Oxford University Press, 1996).

3  Mead, Margaret. *Male and Female* (New York: Harper Perennial, 2001 ed, 1949 org).

4  Vietta, Silvio. *A Theory of Global Civilization: Rationality and the Irrational as the Driving Forces of History* (Amazon Digital Services LLC, 2013).

5   Simon, Herbert A. *Models of Man: Social and Rational- Mathematical Essays on Rational Human Behavior in a Social Setting* (New York: John Wiley, 1957).

6   Ariely, Dan. *Predictably Irrational: The Hidden Forces That Shape Our Decisions* (New York: Harper Perennial, 2008).

7   Toth, C. Rationality and irrationality in understanding human behaviour. An evaluation of the methodological consequences of conceptualising irrationality (*Journal of Comparative Research in Anthropology and Sociology*, 4(1), Summer 2013). pp. 85–104.

8   Church, J. *Reasonable irrationality* (Mind, 96, 1987). pp. 354–366.

9   Davidson, D. Paradoxes of irrationality In Moser, P. *Rationality in Action: Contemporary Approaches* (Cambridge, New York: Cambridge University Press. 1990).

10   Dailey, Anne C. The Hidden Economy of the Unconscious (*Chicago-Kent Law Review*, 74(4), Symposium on Law, Psychology, and the Emotions, October 1999).

11   Gieser, Suzanne. *The Innermost Kernel: Depth Psychology and Quantum Physics.Wolfgang Pauli's Dialogue with C.G. Jung* (Berlin Heidelberg, Germany: Springer Verlag. 2005). p. 137.

12   Gödel, Kurt. Über formal unentscheidbare Sätze der Principia Mathematica und verwandter Systeme, I (*Monatshefte für Mathematik und Physik*, 38, 1931). pp. 173–198.

13   Cartwright, David E. *Schopenhauer: A Biography* (New York: Cambridge University Press, 2014).

14   Duignan, Brian. *Irrationalism* | philosophy Encyclopedia Britannica https:// www.britannica.com/topic/irrationalism (accessed 1 March 2021).

15   Ibid.

16   Miah, Andy. A critical history of posthumanism In Gordijn, B. & Chadwick R. *Medical Enhancement and Posthumanity* (Springer, 2008) pp. 71–94.

17   Zehr, E. Paul. *Inventing Iron Man: The Possibility of a Human Machine* (Johns Hopkins University Press, 2011).

# 3

## HOW ARTIFICIAL INTELLIGENCE INFLUENCES ART

C'est fini, la peinture...Qui ferait mieux que cette hélice?
Art is finished...Who can do anything better than this propeller?
Marcel Duchamp, French-American painter and
sculptor (1887–1968)

Artificial intelligence has already made its entrance into the many facets of art, from the different forms of writing, including prose and poetry, the composition of music, production of movies, as well as photography and painted art. This chapter provides an insight on the current status of machine-generated art, its consequences, and what can be expected in the near future.

Combining artificial intelligence and art might sound as the ultimate expression of futurism, and having machines producing art probably must have been a dream for Marinetti and other worshippers of technology a century ago. Digital art, often sacrilegiously displayed and advanced through computer games, which have been in existence since the 1970s, is perhaps the most articulated digitised art form. In fact, science fiction has been so ahead of actual developments that concepts like post-digital art already can feel somewhat dated. One can consider artificial intelligence from two perspectives:

one is how it serves as an instrument to improve art extending to the algorithms autonomously being able to create art objects, and the other, how artists contemplate and choose to depict a society where artificial intelligence is becoming pervasive to the point that it might crowd out us humans and force us to reflect on the existential concerns that are being pushed to the forefront. This book will deal with both these perspectives, with this chapter focusing on the former, and the rest, and in particular the art manifesto, seeking to outline a way forward on how to artistically relate to artificial intelligence as an integrated part, for both better and worse, of society. The influence of artificial intelligence on art takes its starting point from the highly intriguing man–machine interaction, where, for instance, humanities' experiences and behaviours are being coded as data points, easily available for statistical analysis with a precision only ending at the nth decimal. This not only applies for the proverbial *average Joe* drawn from group samples but, with the data power available, all idiosyncratic patterns at the individual level can be captured to the comprehensive degree that a human's full (online) behaviour eventually will be replicated in algorithms. What previously was seen as uniquely human, and indeed included irrational traits, can now (almost) conceivably be considered to be conducted by machines. As with industrialism in the early 20th century, machines were starting to replace our bodily capabilities with the manual labour they could muster, today artificial intelligence is starting, and has already come a long way, to replace the other key component of the human composition, namely our mind.

It is becoming harder to avoid the question that most realise might have a highly unpleasant answer: what does humanness entail and to what degree is it replaceable? Might art be the conduit to explore and deliberate on such stupendous contemplations?

To start with, how have machines so far been integrated to help form and develop art? Let us consider it with the example of the invention of the camera, where photography over time evolved into its own art form. But it also shaped paintings, perhaps driving them away from the previous genres that promoted exactness, as this was

something which a camera now could represent much better. Or where we currently are in the technical evolution where digital editing, such as *Photoshop*, allows for abilities to express, or mislead, subjects with features that previously was not feasible. Also, technology has facilitated the production of music, now easier than ever, albeit perhaps not yet reflected in any improved quality, an interesting insight that also expands to the other art forms that have been augmented by digital technology. The visionaries and early adopters were quick to embrace these innovations, and as usual it took decisively longer before these contraptions were deployed by the mainstream. Artificial intelligence through its swiftly developing forms is now being adopted and put to work by these pioneering groups on the art scene. And there are impressive examples already, such as *Edmond de Belamy*, a sombre portrait of a man painted in a blurred style which is part of a suite of generative images called *La Famille de Belamy* by the art collective Obvious, which is the first artificial-intelligence-created painting that was sold on Christies auction house in 2018. It is for the layperson at least difficult to distinguish it from something painted by a skilful human hand.

The rest of this chapter includes a description of examples where artificial intelligence already is, or within a short time frame is likely to, influencing the various art forms. Influencing is one thing but is it actually improving it? Consolidating these trends into a few main arguments, we will describe how this is likely to generate potential conflicts or conundrums of various nature, as and when the magnitude of the influence of artificial intelligence on art becomes evident to the parties concerned. But one thing is already clear, artificial intelligence will permanently change how we create, curate, consume, and mediate art, including the philosophical debate on what and who a creator actually will be.

This will include the odd reference to actual technologies, but only to serve as an example of the integration of artificial intelligence into art. However, as the technological development is so swift, we will take aim at the directions of the current technical trends rather than this being a status review, which quickly will become obsolete

at any rate. Important to consider is that applications and tools that at one point were acknowledged as difficult to deploy quickly tend to go in the user-friendly direction and can then be embraced by mainstream users, thus gaining a wider acknowledgement. The below will highlight some of the major art forms and from a general perspective discuss the distinct areas where various artificial intelligence applications might be able to contribute, including:

- analyse and summarise
- generate
- imitate
- translate (mostly relevant for literature)

**LITERATURE**

Natural Language Processing, or NLP for short, has been an important method in linguistics that aspires to replicate our naturally written or spoken language. There are already quite a few relatively sophisticated applications on the market; however, what they can produce would typically still not be mistaken for "natural" language. As when reading an NLP-generated text, something mechanical in the syntax or morphology discomforts the feeling that it actually could be written by a human. Currently, these tools are mostly used for translations, summarising long chunks of text or trying to appraise sentiments from a text. NLP is not a new technology, its first versions appeared in the 1950s, but have gone through a suite of generational upgrades and are in the latest versions based on neural networks, with an algorithm named GPT-3 being the latest base technology. Through slick promotion, it has created quite a stir, already its predecessor GPT-2 was by its makers branded as dangerous to humanity given its close approximation to general intelligence when it comes to text generation, however a claim many sceptics refuted. But, the firm decided to withhold it from release for a year, and in that time span competing applications had already surpassed its claimed performance, and they had to opt for a version upgrade. Hence GPT-3 now aspires to be

"the greatest threat to humanity", and access to it is only through licensing to a selected few and is not yet available for purchase on the market. Whilst that might have been a clever marketing strategy to get the desired attention, it does shows how quickly acclaimed cutting edge technology is becoming obsolete. The capability of the GPT-3 technology is enabled through an autoregressive language model based on neural networks. The reason that it, and similar algorithms, is currently getting traction is that it is uniquely based on multi-parameter approach rather than earlier artificial intelligence technologies that were focused on "summarising" and vaguely predicting intention or suggesting statistical likely choices. Thus, it has been trained on enormous amounts of text downloaded from the internet, and created a data model with 175 billion parameters, more than ten times the previously best trained model; Microsoft's Turing NLG, and its previous version, the GPT-2 model had a mere 1.5 billion parameters. With the capacities of these neural network-based models accelerating at a seemingly breathtaking speed, will it within a short time start to impact literature so that we soon might have machine-generated poetry and prose?[1,2,3]

## ANALYSE AND SUMMARISE

An important skill for an author is the ability to observe aspects of reality and in an engaging way analyse and prepare a story out of it, either in prose or poetry. Basically, an ability to succinctly articulate thoughts and perceptions into text. This very human quality needs to be understood and enabled by the core function of artificial intelligence, namely to statistically facilitate analytics and regressions in order to find patterns amongst a collection of data and to formulate these findings into equations, or similar. Whilst this might feel clinical and mechanic, the method broadly resembles what an author that gathers impressions tries to do, albeit never articulated in such statistical terms. To find some type of order (sometimes any type) in what appears chaotic to a large degree captures the gist of creative work. When an artistic piece of work is considered successful

or groundbreaking it is often done with a spectacular twist that somehow brings a new perspective to the contemporary audience. Therefore, a new sort of artistic order emerges from the chaos that usually takes some digestion before it can be fully appreciated. There are already algorithms capable of grammatically identifying language patterns; however. the semantic quality remains an issue. Through deep learning and with access to extensive text material for training, the algorithms have been continuously improving, getting closer and closer to what can resemble natural language. An important feature that some artificial intelligence models include is sentiment analysis, such as recognising whether the underlying narrative is positive or negative. The algorithm identifies unique markers in the text that provide insights on what type of sentiment it conveys. However, a considerable weakness still remains in the correct interpretation of ambiguities, such as ironies, however it is a weakness that indeed extends to many humans as well.

## *GENERATE*

The infinite monkey theorem holds that if a monkey hits keys at random on a typewriter for an infinite amount of time, eventually it will be likely to type out the complete works of William Shakespeare. A mesmerising notion and previously mostly an amusing talking point, but now it is nearing practical applications as through the access of significantly increased computer power allows for generating almost endless variations of a text. With the aforementioned GPT-3 model, producing such wide varieties of text is now something considered feasible. It works in short, such that a large amount of text is fed into the model and is processed by the algorithm. Then, the algorithm is loaded with a short text, and through the use of statistics, the model produces a guess of what the next sentence to this short text might be, and then use that sentence to guess the next one and so on. To generate shorter social media texts, such as tweets, this has proven a highly useful tool. Whilst models such as GPT-3 yet are far from creating "perfect" literature autonomously, they can create a great number of text variations

from which then an editor can select interesting perspectives or ideas to keep working on in the preparation of a novel, for example, and omit any nonsense, rather than starting to write from scratch. Thus, it can already serve as a creative aid to authors by generating fragments of texts that contain new original insights that might be the trigger that renders a bestseller. And for poetry, usually shorter in size than prose, artificial-intelligence-generated smaller pieces of poetry can be very helpful to promote that creative spark many authors struggle with and help overcoming writer's block.[4,5,6]

## *IMITATE*

From the artistic perspective, the ability to analyse and summarise as well as generate can be productively combined into enabling the possibility to imitate. One way to approach imitation is to train an artificial intelligence model on certain types of text, such as poetry, with the objective that the model will be able to reinforce and extend on certain language patterns. As an example of what that can look like is an artificial-intelligence-induced imitation based on William Shakespeare's Sonnet 18, as in Figure 3.1).[7]

For this example, the algorithm has been trained on Shakespeare's work, and based on the first paragraph, it can generate lyrics that at the superficial level at least do align with the original and becomes difficult to distinguish from the authentic work of Shakespeare. Some algorithms are now able to distinguish between text written by an author vis-à-vis ghost writers operating under an assumed identity. Current tools allow for vastly improved text editing than what only the previous generation of editing tools could do; hence, by merely setting a tone in a text, these tools could help perfect it through mimicking the style of famous authors or just help to generate a random structure, this can then be combined with the more ordinary editing features such as autowrite. In journalism, the autogeneration of linear, repetitive, shorter-style summary articles without readers actually noticing has led to controversies, and can in that context extend to when can a machine-generated text be considered as art?

**"Sonnet 18"**
**William Shakespeare**
**Shall I compare thee to a summer's day?**
**Thou art more lovely and more temperate:**
**Rough winds do shake the darling buds of May,**
**And summer's lease hath all too short a date;**
A winter's day, when beams of sun are few,
And skies are grey with clouds intemperate,
Is to thy beauty somehow sordid grown.
Her lovely-lovely eye is quite shut up,
Like windows pale before a sunny shower.
The earth that's cold and moist, like to my mistress,
When once that she unbrac'd, her lovely jewel,
Grows as both ugly and uncourtly.
Poor soul, the center of my motley host,

**Figure 3.1** Shakespeare's Sonnet 18 expanded on through artificial intelligence.

In all, artificial intelligence tools are now able to:

- help produce newspaper articles, facilitating and speeding-up the collection of documentary information
- aggregate narrative elements from vast databases of verbal and visual information to get indications on the main trends of story-telling in specific areas
- identify the prevailing emotional arcs and point out the most successful ones, which can be used for new creative projects
- study new variations of stories/films' narrative models and new sequences beyond the usual ones
- support those who work on song lyrics by making available sophisticated combinations from large lyrics databases
- increasingly enrich the experiences of interactive storytelling and improvisational storytelling
- analyse huge amounts of Big Data on consumer behaviour to inspire advertising creativity

- propose new hypotheses of formats and solutions for brand communication
- provide narrative elements useful to inspire storytelling for training purposes on specific corporate or institutional themes
- help set up political discourses by identifying the issues that most interest the public
- find political and social slogans through the large-scale combinatorial elaboration of keywords
- facilitate the interweaving of storytelling forms with innovative virtual reality and augmented reality solutions[8,9]

## *TRANSLATE*

Most are today familiar how online translation services work, they generate translations, often relatively good, however never perfect and at times outright weird, given the typical word-for-word translation style. But like most other areas of artificial intelligence, the improvements in translation functions have been remarkably swift. What currently starts to be possible is to augment these machine-generated translations by combining the summarising and imitation capabilities, which allows for capturing the gist of a text and then translate it in a more free-flowing fashion providing a more natural feel of the translated text. This rather than a word-for-word method or using text style-to-text style to replace offensive language with euphemisms, for example.

## MUSIC

Music is perhaps the art form that so far has seen the greatest impact of digitalisation in terms of the tools been made available for the creators of music, and it might also be so that this evolvement has influenced how and what we experience as music. Given music's more looser boundaries and an easier to manipulate medium of art, it is likely to be the art form where artificial intelligence will first be able to operate entirely autonomously. The composing of music no

longer requires the ability to play an actual instrument nor the ability to read or write musical scores due to the advances in digital tools. These have already created new melodies, regarded as so unique so that they can withstand the scrutiny of anti-plagiarism tools. The creation of music is now a possibility for almost everyone. In practical terms, this means that a raft of software, services, and tools that allow for the sampling of music, creation of loops and autotune as examples, will help to facilitate the creative process. Music services including *Apple Music* and *Spotify* have made it possible to find an almost infinite number of songs that one can arrange in accordance with individual preferences.[10,11,12]

It has not only democratised who can make music but additionally the qualitative assessment of it; listeners no longer are so dependent on the opinions from music journalists, DJs from radio stations, and so on, but they can orient themselves in a greater degree free from these kinds of filters. The artists are also less reliant on intermediaries and curators to distribute their music directly to the audience, the challenge now is instead to stand out and be identified in the crowded space of aspiring and recognised artists. Hence, the net effect might not be that significant, as the audience now rely on the statistics collated by the music services' algorithms that provide insights on listening patterns based on demographics, geography, timelines, and similar characteristics, with the objective to individualise the listening experience. These algorithms go hand in hand with how online shopping algorithms have evolved by collecting data on purchasing patterns and seeking to customise the shopping experience by inciting potential customers with bespoke advertisements and offerings.

The next generation of algorithms is now trying to capture the consumer's mood, that by through ascertaining and measuring these can tailor the offering of particular music so that it is aligned with the specific mood that dominates an individual or one that they are aspiring towards, such as happiness. Whilst this personalisation might be more about distribution than the art form itself, it does provide a picture of what might be possible within a short time,

where artificial intelligence can individualise the music itself to fit a certain person. A sort of composing on the go, perhaps at first to provide slight variations of existing music, allowing for changes in tune, pace, duration, alteration of scales, or lyrics. All these factors are adjusted to fit the bespoke experience of the listener at that particular time, at that particular moment. However, and interestingly enough, as this is the art form that has been most exposed and influenced by artificial intelligence, there is still no conclusive evidence that it has led to a noted improvement in quality, perhaps quite the contrary, as imitations appear abundant, with alterations in nuances rather than radically new compositions being produced.

## ANALYSE AND SUMMARISE

Algorithms have allowed for a better understanding of listeners' musical preferences, this by collating, analysing, and assessing a raft of personal details, including mood, with the aspiration to understand what music styles are preferred before creating it. Hence, the commercial objective is to avoid large productions without being certain there actually is a demand for it. Thus, music is becoming bespoke down to eventually being created for single individuals. Algorithms have also been crafted to identify melodies resembling each other musically, this to prepare better lists of song recommendations based on metrics such as beats per minute/rhythm, by identifying which instruments that are included, and tones and melodies matched on how close they are. But also "hidden" structures can be identified through the power of artificial intelligence algorithms, extending to find what it is that makes a certain composer or artist unique. Once these traits have been isolated, analysts can seek to improve them, and the possibilities for a *Wolfgang Amadeus Mozart* 2.0 is then a viable prospect. They can also detect certain passages of a song that arouse emotions, and by registering and isolating that particular phase, music can be deliberately produced to trigger such emotions, this, for instance, to influence crowds in desired directions.[13,14,15]

## GENERATE

The same technology used in the GPT-3 model based on neural networks for text generation can also be employed for the creation of music. Through training it on large amounts of music, loading it with a short melody or sequence, the aspiration is that the model will be able to extend it to a complete tune. Whilst still in an early stage, one can already foresee that this ongoing technical trend will allow algorithms to create works of music comparable to that of a skilful human composer.[16,17]

Like for literature, lyrics for songs can be machine generated in a similar way, something already possible, in particular for the more trivial popular lyrics. So, by simply humming a song, which an artificial intelligence with audio capacity can record, then analysing its musical structure, it will be able to create a melody, and even provide it with suitable lyrics, such as rhymes. Hence, algorithms can already partake in the creation of music, albeit not yet covering the full creative process or being able to act autonomously.

This possibly starting in a piecemeal basis, where algorithms on command can generate short musical samples as inspiration in jam sessions. Or as placeholder for text or music jingles for instruments that have still not been produced, much in the way movie producers are overlaying suitable music on scenes prior to the musical scores actually have been produced, simply to provide a glance of the final product. The music samples might in the future need not be a segment of musical scores, but over time algorithms can be fed works of musicians or a selection of tunes, allowing them to find common denominators and create bespoke music out of it.

## IMITATE

With the highlighted capabilities, imitation becomes a viable possibility through adjusting the algorithm and emphasising the desired musical genre, in the same fashion as it was created in literature for the Shakespearian example. There is however another interesting

feature made possible through so-called deepfakes where voices of famous singers for instance now can be copied almost to perfection, requiring only a relatively small amount of audio files to train the algorithm. Thus, the creation of a new Elvis Presley is a distinct possibility. Therefore, artificial intelligence would not only be able to create the rock'n'roll songs of the similar nature that Elvis Presley used to sing but also replicate his voice.

### *TRANSLATE*

Algorithms will allow for songs in, for instance, Spanish to be translated into English, and what more is, once more free-flowing translation models become available, the translations would not exclusively be word-to-word but arranged so that also the English lyrics would rhyme and fit the melody much as the original Spanish version does whilst keeping the gist of the content. Translation can here also be considered from its broader context, as an algorithm could automatically translate a melody played on a flute to a piano arrangement and so on, changing tempo and even genre, such as classical tunes being played in a rock'n'roll style, much like the ability of a cover artist.

## VISUAL ARTS

The concepts digital art or computer-generated art probably give art connoisseurs associations to visual-algorithm-generated works of arts, such as mathematical patterns. And artificial intelligence will provide ever more possibilities to create artistically advanced abstract generative art. One here needs to clearly distinguish between painted art and photo art, where the latter nowadays is almost fully digitalised, and where a lot of tools have been developed to help manipulate an original photo to the point that it can become largely unrecognisable, and where fake photo arrangements are hard to distinguish from authentic ones. It is creating an altered reality which, for instance, imposters with fraudulent intent already are exploiting. Most are familiar with the artificial-intelligence-based filters applied

on cameras in most mobile phones that can be immediately edited to enhance portraits, where the algorithm locates where on the photo the face is positioned and then optimises the best way to improve looks. Or there are now editing software that can transform a photo into an oil painting. The variations on how to enhance photos including transforming them into other art forms is quickly evolving, one current example is Google's *Deep Dream Generator* that through neural networks is able to produce dreamlike, almost hallucinatory pictures of photos.[18,19,20,21]

## ANALYSE AND SUMMARISE

Photo analysis such as facial recognition is a well-known feature nowadays, often used as an example of the power of artificial intelligence for educational purposes. Much like text analysis, an algorithm can identify the essential parts of individuals and objects in an image or try to identify the mood of a person by scanning and ascertaining facial features typically linked to emotions to, for example, determine whether the person is happy or sad. It is also a technique commonly deployed to identify contents in photos or movies deemed not suitable for children. As these algorithms are improving their capabilities, they are being designed to be able to identify the unique painting patterns of certain artists, whether that be colour composition, brush strokes, or similar features. Hence, once these idiosyncratic patterns have been documented they can be replicated and even improved.

## GENERATE

An easy method to generate art is to combine two or more images and create something altogether new, a skill that artificial intelligence applications can quite easily perform nowadays. There are a number of methods for this technique, but one fascinating capability is to from a raft of portraits create photos of humans that

does not exist to a quality that makes them indistinguishable from photos of genuine people. A currently developing technology, based on the GPT-3 technology, is Wall-E, which aspires to generate an image from interpreting words in a text and then depicting them. And like text and music, an algorithm can be fed a partial picture, and then based on the assessment of it, through being trained on millions of images, fill in the blanks to generate images of what does not exist. These kinds of algorithms can be used to improve works of art from mathematical and logical patterns, such as Mandelbrot's fractals.[22,23,24,25]

## *IMITATE*

Imitate here is considered from the perspective of imitating a painter. Albeit, still at an early stage, there are algorithms trained to imitate images, and theoretically an artificial intelligence model should be able to, by analysing the works from a particular painter, identify the idiosyncratic features, then comprehensively replicate it, also by deploying a robotic arm to mimic brush strokes and the more physical characteristics required to produce a painting. As an amusing feature, one could then imitate Claude Monet's or Vincent van Gogh's painting styles and apply these on a modern motif such as an airplane or space shuttle. It can also mean an ability to imitate a false reality into an image or a painting, which currently is possible with digital design software, such as *Photoshop*. Even if that currently might be a time-consuming process; however, over time it has become considerably user friendly and faster, such as generating an image of person X at location Y doing Z. Fakes and malevolently manipulated photos have long been an issue highlighted through the infamously altered photos of Lenin and the removal of political enemies to Joseph Stalin, and through advanced applications, the ability to detect fakes will be subject to an ever-escalating arms race and close to impossible for the naked eye.[26,27]

## MOVING PICTURES

Moving pictures is, from the technical perspective, a more complicated art form than literature or music. To start with, movies are a combined form of the other art forms, images, sound and text; thus, what applies for these as discussed above will be as relevant for moving pictures, however, adding a holistic dimension. The relative complexity of movie making versus its individual components means that an algorithm would not, for now at least, be able from having been uploaded with a short film sequence continue to, based on it, produce a full movie, regardless of how many movies it has been trained on. And whilst, in particular, editing and post-production work have become notably easier than before, the digital tools in themselves do not provide any reassurance that they are raising the overall quality. Nor would it be able to single-handedly and convincingly produce a movie based on merely the text from a manuscript. Attempts have been made but are as of yet in an early and rudimentary stage. A movie's rhythm and visual tone or the mood of the story might be possible to be summarised but to combine the many subplots that might be running in parallel and any ambiguities that might be displayed by the actors, both in their language and mannerisms which is an ingredient that often defines the quality of a movie, are so far not possible to automatically generate. To satisfactorily capture and amalgamate all features is an undertaking that at the time of writing artificial intelligence is far from being able to achieve. However, as for music, the advancements in technology have democratised film making, in that movies can be produced on quite small budgets, with less technical skills required, which has allowed for sub-genres, such as indie movies, to evolve and find an audience. Hence, at the superficial level at least, the making of movies has been greatly facilitated, helped by blue screens and digital technology, but as with the other art forms, technology can still only do so much. The quality of the artwork still largely depends on the human artist, and so far it is hard to detect any distinct quality improvements vis-à-vis earlier less tech-equipped and tech-savvy generations.

## ANALYSE AND SUMMARISE

It is already theoretically possible to extract what is happening in a movie, through artificial intelligence recognition applications, including action scenes with its explosions, locations, ambiance and how actors are performing and collating these to develop a database of characteristics which can be replicated into other movies. However, it is an emerging technology as from deconstructing a movie through its various facets and then have an algorithm comprehensively understand it and from the individual bits and holistically building a movie requires technologies and coordination abilities not yet available.

## GENERATE

From the perspective of video art, the generative capability has advanced further than for movies proper. It would today be possible to analyse film sequences or photos in relation to music with the view to automatically generate music videos to fit the cinematic arrangements, and in particular for generative art where it would be possible to use artificial intelligence to produce video patterns suited for a bespoke work of music. For animated movies, the ability to generate is easier, as already today there are tools for animating "frames" from start to end to enhance the visual effects of the animations. It is an area which should within a relatively short timeframe be able to reach the stage of autonomously generated animations and create a movie, albeit simple, from instructions such as *a rabbit and his friend the turtle walk across the meadow gossiping about the toad*, although for now algorithms can only create static photos of such text interpretations. There are now certain services that can offer a full range of artificial-intelligence-enhanced movie productions. *Charisma.ai* is one such company offering a new dimension of storytelling: re-playable, interactive conversations with characters crafted with emotions, memories, and voices. The service range also includes components such as a story editor and a chat engine.[28,29]

## *IMITATE*

The most interesting breakthrough this far with regard to moving pictures are deepfakes. Here artificial intelligence is used to project human appearances on moving pictures where they really do not exist. In a similar manner as is it possible to emulate a human's language, this technique, deploying a type of neural networks, generative adversarial networks (GAN), allows for replicating an individual's face with its idiosyncratic facial moves, or bodily movements. It means that an actor can be altogether replaced by another actor or let the algorithm adjust the face of an actor to make them appear younger to better fit the role. Whilst these technologies today are expensive, the ongoing digitalisation will lower the price and open up for a broader set of users to deploy these technologies. Obviously, it raises the question of the future role of the actor, if at all required, and their price tags.

## INTERACTIVE ART, UPCOMING ARTFORMS, AND HUMAN INTERFACES

With the introduction of artificial intelligence, there are many art forms that have rarely been considered mainstream, perhaps not even regarded as art at all, which will now have opportunities to evolve into more highly regarded artistic undertakings. Artificial intelligence might actually form the edifice of such art forms, the very pinnacle allowing them to expand into more fully fledged manifests, even in ways perceived as revolutionary. Interactive (digital) art is such an example, where art installations both have physical and digital representations. Another area is works of art in Virtual or Augmented Reality with the creation of three-dimensional art, which is an onerous and highly labour-intense creative procedure and yet only exists in rudimentary forms. Through enabling the possibilities that Virtual or Augmented Reality provide, a more advanced "human to computer interface" will eventually emerge, which is considerably more advanced than the relatively simplistic graphical tools that

are currently being used. For art produced through Virtual or Augmented Reality, some of the insights that the artificial intelligence features provide include:

- The notion that art is really nothing else but patterns created to capture and pique the interest of a potential audience. These impressions can be measured and then reinforced through dynamic tools that are able to capture the "intensity" of the interaction. Examples include the functions that adjust settings and surroundings which are not part of authentic photos to produce a more desirable background.
- Combined with deepfakes that already are an integrated feature in some movie productions, and additionally paired with all other technologies, it allows for the creations of an entirely fake reality. Therefore, these digital capabilities can be created much more cost-efficiently than the currently hand-crafted methods which are too complicated and costly to be routinely deployed.

As now almost being in the twilight zone between reality and digital arrangements, it is set to enhance the emotional experience of the audience. This by not only expanding the impression beyond starring into a screen but through facilitating more possibilities for an artificial intelligence model that continuously can analyse the spectators' reactions and adjust the visual and other perceptions to generate a peak experience of sorts of the artwork. This interactive capability is one of the most attractive features that artificial intelligence is contributing and it will include some of the following characteristics:

- The interactive feature holds a potential conflict between the recipient reacting to a signal and the creation and unfolding of a story or pattern with the unexpected and hard-to-fathom abstract twist of a story plot, for example, never actually materialising. However, it provides for a better possibility to effectively communicate an intended message.

- It provides better opportunities to analyse the interaction from the perspective of the recipient to understand preferences and adjust accordingly.
- It gives possibilities to provide added interactive capabilities for literature, such as an algorithm generating a poem and through the observation of the audience's reactions, initiate virtual conversations chatbot style that promotes dialogue and enhances the audience's cultural experience. It can facilitate numerous options based on the feedback it gets, not merely narrowed down to a few hard-coded options but allowing for enriched dynamics. The *Dungeon Adventure* game is one example on how the GPT-3 technology is trying to incorporate more generic interaction rules, something which until now has been a challenge given the many possibilities that can arise, and which previously had to be manually coded.[30,31,32]

## THE FUTURE ROLES IN THE WORLD OF ARTS

As this chapter has highlighted, the various art forms have advanced at different speeds and proven differently suitable to adopt artificial intelligence; however, it is inevitable that all of them will be affected as the technology continues to advance and becomes available to the mainstream. In addition to how it will affect the creative process and production of works of art, there is a broader consideration at the meta level in how it will influence the understanding of art and its role as part of the human condition. Currently, the production is finite in that the number of artworks that can be produced is decided by the number of active artists, adding to the legacies of the departed ones. With algorithms producing art, the number can approach infinity, it could, for instance, produce a billion variations of Leonardo Da Vinci's *Mona Lisa* or Ludwig van Beethoven's *Symphony No. 5*, or it could create something entirely new, also counting in billions, such as new novels or poems. By understanding which of these variations, even if it is only a single one that might titillate the human taste based on not only technical qualities but also the fickle

tastes that sway in sometimes baffling ways, an artificial intelligence model calibrated to pick up on these features can continue to create new variations basically seeking to find perfection in whatever way, form, or shape that is to be measured. But unlike the artist, an algorithm has no conscious insight to what it is that it has created, good or bad, hence the tale with the monkey randomly keying in letters on a typewriter is so very apt, sooner or later, and probably later, a masterpiece is likely to be generated autonomously by an algorithm. However, it is reliant on the response and feedback from humans that can provide the aesthetic judgement to guide the production of artworks. Albeit in the future, algorithms might have been so conducively trained on the variations of human preferences that it also can act as a qualitative judge. However, as it lacks human consciousness, it will not understand what it is that it actually is doing, merely being a suite of statistical models in effect calculating favourable odds through an enormous number of variations. Generating art thus needs to be distinguished from creating art, as artificial intelligence cannot provide new ideas based on a (sudden) insight of how to view the world and the ambition to proclaim and promote it to fellow human beings in the aspiration of some higher spiritual means. It lacks creativity in the sense that we understand that concept, sometimes art produced just for provocative reasons and so on. But it can, through its sheer capacity of generating variations, also random such, being of a serendipitous nature, even bizarre, act as a sparking trigger of inspiration to the artist applying algorithms to augment the artistic process.

Artificial intelligence will eventually, if not already so, be perceived as a threat by artists in the different disciplines, through its vast capacity to imitate. One can assume that this threat will be most greatly felt amongst the second-tier artists that rarely provides innovative and creative works of art but make their living of in effect being copyists rather than genuine artists. Artists making careers of plagiarising might see their career coming to an end, standing little chance to outmatch whether in terms of quantity or quality machine-generated art. The role of the curator might also

be challenged; the grouping of artworks into collections which till now often has been the prerogative of the curator's gut feel and extensive experience will be systematically replaced by an algorithm able to gather much more data points of preferences, and suggest allocations of art, eventually likely to be a lot better than even the most experienced curators. This might also extend to the very definition of what art is, perhaps it is no longer the art critiques, but an algorithm able to identify hidden (unconscious) preferences amongst the audience that allows for objects previously not considered as art to be elevated as artworks. This will obviously also influence how art is valued, the appraisal by individual art critiques and curators might be replaced again by algorithms being able to identify "uniqueness" in an entirely new manner that will drive the value of one piece of art versus another. Hence, roles such as curator, music critique, artistic leaders, disc jockeys, and similar roles are likely to come under threat. Their roles as definers of what constitutes good art, in the broadest sense of the word, might be made redundant. The creation of completely new combinations, previously unthought of, of which some might be, by the audience, regarded as truly innovative might be the greatest contribution from artificial intelligence. These potentially contentious areas will be the battlefields where the questions on the definition of art and how art is assessed are likely to be settled. As important will also be who the creator of art is, the algorithm or the creators behind the algorithms? At the core stands the reflection what it means to be a human versus how close artificial intelligence can capture this humanness. As long as artificial intelligence lacks the intrinsic understanding of the concept of ideas, shall it merely be regarded as a tool, albeit sophisticated, or will the quality of its work by itself define it as sufficiently autonomous to equal that of a human artist? However, to consider the programmer coding the algorithm instructed to act autonomously in its creation of art as the artist is a stretch as much as a parent who in addition to providing favourable genes but also a fruitful grooming of their child should be consider as the artist and take claim of the child's works

of art (something that does routinely happen). The questions of copyrights and intellectual property with a machine generating capability being at ease with imitating in enormous numbers and variations, ever so slight, will be a serious concern for the foreseeable future.

## NOTES

1 Dale, Robert. GPT-3: What's it good for? (*Natural Language Engineering*, 27(1), January 2021). pp. 113–118. https://www.cambridge.org/core/journals/natural-language-engineering/article/gpt3-whats-it-good-for/0E05CFE68A7AC8BF794C8ECBE28AA990 (accessed 1 March 2021).

2 Heaven, Will Douglas. OpenAI's new language generator GPT-3 is shockingly good—and completely mindless (*MIT Technology Review, Artificial Intelligence/Machine Learning*, 20 July 2020). https://www.technologyreview.com/2020/07/20/1005454/openai-machine-learning-language-generator-gpt-3-nlp/ (accessed 1 March 2021).

3 Simonite, Tom. Did a Person Write This Headline, or a Machine? (*Wired*, Business 22 July 2020). https://www.wired.com/story/ai-text-generator-gpt-3-learning-language-fitfully/ (accessed 1 March 2021).

4 Eliza Strickland. OpenAI's GPT-3 Speaks! (Kindly Disregard Toxic Language) (*IEEE Spectrum*, 1 February 2021). https://spectrum.ieee.org/tech-talk/artificial-intelligence/machine-learning/open-ais-powerful-text-generating-tool-is-ready-for-business (accessed 1 March 2021).

5 Seabrook, John. The Next Word. Where will predictive text take us? (*The New Yorker*, October 14, 2019 issue). https://www.newyorker.com/magazine/2019/10/14/can-a-machine-learn-to-write-for-the-new-yorker (accessed 1 March 2021).

6 The Economist. A new AI language model generates poetry and prose (*The Economist, Science & Technology*, 8 August 2020 edition). https://www.economist.com/science-and-technology/2020/08/06/a-new-ai-language-model-generates-poetry-and-prose (accessed 1 March 2021).

7 Gwern Branwen. William Shakespeare. Transformer AI poetry: Poetry classics as reimagined and rewritten by an artificial intelligence (*GPT-3 Creative Fiction*, 28 September 2020). https://www.gwern.net/GPT-3#william-shakespeare (accessed 1 March 2021).

8   Nichols, Greg. AI can write a passing college paper in 20 minutes (*ZDNet*, February 24, 2021).https://www.zdnet.com/article/ai-can-write-a-passing-college-paper-in-20-minutes/ (accessed 1 March 2021).

9   Khalili, Joel. AI will soon outperform us in disciplines we thought were uniquely human (*TechRadar*, January 23, 2021). https://www.techradar.com/in/news/ai-is-on-the-verge-of-mastering-the-creative-arts (accessed 1 March 2021).

10  Mehta, Ivan. Google's new machine learning tool turns your awful humming into a beautiful violin solo (*The Next Web*, 1 October 2020). https://thenextweb.com/neural/2020/10/01/googles-new-machine-learning-tool-turns-your-awful-humming-into-a-beautiful-violin-solo/ (accessed 1 March 2021).

11  Borowska, Kasia. The Role Of AI In Music Curation & Creation (*Forbes*, 23 September 2020). https://www.forbes.com/sites/kasiaborowska/2020/09/23/the-role-of-ai-in-music-curation--creation/?sh=73497aea6272 (accessed 1 March 2021).

12  Deahl, Dahni. AI co-produced Taryn Southern's new album (*The Verge*, August 31, 2018). https://www.theverge.com/2018/8/31/17777008/artificial-intelligence-taryn-southern-amper-music (accessed 1 March 2021).

13  Hao, Karen. Create your own moody quarantine music with Google's AI (*MIT Technology Review*, 4 September 2020). https://www.technologyreview.com/2020/09/04/1008151/google-ai-machine-learning-quarantine-music/ (accessed 1 March 2021).

14  Music Ally. Loudly shows off AI tech to remix songs into different genres (*Music ally*, March 5, 2020). https://musically.com/2020/03/05/loudly-shows-off-ai-tech-to-remix-songs-into-different-genres/ (accessed 1 March 2021).

15  Nelson, Daniel. *OpenAI Creates New AI Program To Create Music Based On Genres* (Unite.AI, 3 May 2020). https://www.unite.ai/openai-creates-new-ai-program-to-create-music-based-on-genres/ (accessed 1 March 2021).

16  Dhariwal Prafulla, Jun Heewoo, Payne Christine, Kim Jong Wook, Radford Alec, Sutskever Ilya. *Jukebox: A Generative Model for Music* (Cornell University, 30 April 2020). https://arxiv.org/abs/2005.00341 (accessed 1 March 2021).

17  Hart, Matthew. *This 'Jukebox' AI Generates Complete Songs* (Nerdist, 5 May 2020). https://nerdist.com/article/jukebox-ai-generates-complete-songs/ (accessed 1 March 2021).

18  Hao, Karen. Inside the world of AI that forges beautiful art and terrifying deep-fakes (*MIT Technology Review*, 1 December 2018). https://www.technology review.com/2018/12/01/138847/inside-the-world-of-ai-that-forges-beautiful-art-and-terrifying-deepfakes/ (accessed 1 March 2021).

19  Borak, Masha. *AI paintings of Chinese landscapes pass as human-made 55 per cent of the time, research by Princeton student shows* (South China Morning Post, 4 December 2020). https://www.scmp.com/tech/innovation/article/3112358/ai-paintings-chinese-landscapes-pass-human-made-55-cent-time (accessed 1 March 2021).

20  Fujishima Kenji, AI Gahaku. Your Latest Artificial Intelligence Art Obsession (*Fine Art Globe*, 6 April 2020). https://fineartglobe.com/news/ai-gahaku-your-latest-artificial-intelligence-art-obsession/ (accessed 1 March 2021).

21  Miller, Arthur I. *DeepDream: How Alexander Mordvintsev Excavated the Computer's Hidden Layers* (The MIT Press Reader, 1 July 2020). https://thereader.mitpress.mit.edu/deepdream-how-alexander-mordvintsev-excavated-the-computers-hidden-layers/ (accessed 1 March 2021).

22  Goodfellow Ian J, Pouget-Abadie Jean, Mirza Mehdi, Xu Bing, Warde-Farley David. Ozair Sherjil. Courville Aaron, Bengio Yoshua. *Generative Adversarial Networks* (Cornell University, 10 June 2014). https://paperswithcode.com/method/gan (accessed 1 March 2021).

23  Ehrenkranz, Melanie. Here's DALL-E: An algorithm learned to draw anything you tell it (*NBC News*, 27 January 2021). https://www.nbcnews.com/tech/innovation/here-s-dall-e-algorithm-learned-draw-anything-you-tell-n1255834 (accessed 1 March 2021).

24  Brownlee, Jason. *18 Impressive Applications of Generative Adversarial Networks (GANs)* (Machine Learning Mastery, July 12, 2019). https://machinelearning mastery.com/impressive-applications-of-generative-adversarial-networks/ (accessed 1 March 2021).

25  Radford, Alec, et al. *Learning Transferable Visual Models from Natural Language Supervision* (Open AI, 5 January 2021). https://cdn.openai.com/papers/Learning_Transferable_Visual_Models_From_Natural_Language_Supervision.pdf (accessed 1 March 2021).

26  Jhala, Kabir. An AI bot has figured out how to draw like Banksy. And it's uncanny (*The Art NewsPaper*, 23 October 2020). https://www.theartnews paper.com/news/ai-generates-fake-banksy-algorithm (accessed 1 March 2021).

27 Barnes, Sara. *Artist Uses AI to Generate Realistic Faces of Subjects from World's Most Iconic Paintings* (My Modern MT, 15 July 2020). https://mymodernmet.com/denis-shiryaev-neural-network-art/ (accessed 1 March 2021).

28 Gault, Matthew. *Artist Uses AI to Recreate 'Watermelon Sugar' Music Video Using Footage of Ronald Reagan* (Vice Motherboard, February 17, 2021). https://www.vice.com/en/article/4ad8ew/artist-uses-ai-to-recreate-watermelon-sugar-music-video-using-footage-of-ronald-reagan (accessed 1 March 2021).

29 Smith, John R. IBM Research Takes Watson to Hollywood with the First "Cognitive Movie Trailer" (IBM Blogs, Cognitive Computing, 31 August 2016). https://www.ibm.com/blogs/think/2016/08/cognitive-movie-trailer/ (accessed 1 March 2021).

30 Deoras, Shrishti. *The Rise and Rise of AI Gaming Industry* (Analytics India Mag, 24 February 2021). https://analyticsindiamag.com/the-rise-and-rise-of-ai-gaming-industry/ (accessed 1 March 2021).

31 Ibid.

32 Barnes, Sara. *Artist Uses AI to Generate Realistic Faces of Subjects from World's Most Iconic Paintings* (My Modern MT, 15 July 2020). https://mymodernmet.com/denis-shiryaev-neural-network-art/ (accessed 1 March 2021).

# 4

---

# THE ARTIFICIAL
# INTELLIGENCE ART
# MANIFESTO

It's not wise to violate rules until you know how to observe
them.

T.S. Eliot, British/American poet (1888–1965)

Whilst artificial intelligence is permeating across most areas of life,
and as noted already left its mark in the art world, the communities
of artists has not really related to it through art manifestos. Sure,
there have been a few attempts, avantgarde in nature, but typically
confined to individual genres, and these have rarely been followed
through or gained general acceptance but over time largely faded into
oblivion. Cyberpunk, Transhumanist Art Movements, Post-digital art,
and others typically carrying the prefix *cyber-* or *digital-*, all do have
some merits but having entered the upgraded version of the digital
age with artificial intelligence now being the flagship methodol-
ogy, they appear not all-encompassing, not universally applicable,
and their artistic reflections generally too bent towards sensationalist
sci-fi depictions and at times crossing the border to the frivolous.

Why is this? It could be that the technology is evolving so quickly
that it is difficult to get the full grasp of where this is going. It might
also be that crafting an art manifesto in our fragmented world, where

information overload must always be accounted for, is making it hard for us, artist and layman alike, to comprehensively convey any universal tenets that can be applied in such a way that it transcends all art forms. The technological world is simply spinning too fast and too much. Also, art as a form of protest might nowadays be seen as too subtle to make a lasting impression as we are already bombarded with a plethora of opinions and views from a diverse range of social media platforms. Hence, an art manifesto intent on contemplating and acting on the impact of artificial intelligence not only for the evolvement of artistic manifests but the influence on society at large is still an endeavour to be considered as an act in progression. That however does not mean we should refrain from trying, and we are not without some quite compelling historical precedents as we have encountered machines before when they ushered us into the era of industrialisation. With these acting as guidelines and templates, and with the benefit of hindsight, we realise that art manifestos really are important documents that help us navigate in a quickly changing landscape and provide us with artistic forms of expression to articulate existential concerns, utopian hopes, and a whole raft of deliberations in between. Humans equipped with an artistic apparatus, aligned to fit contemporary challenges, do carry great therapeutic properties which if properly applied can deliver momentous qualities which empowers us as humans and elevates us to get a better handle of a future set on an unusually unpredictable trajectory. The perpetual pendulum between hope and despair is allowed to roam freely within these boundaries of artistic techniques and preferred motifs until it abates and stagnates and forces us out on a new artistic quest.

## THE ART MANIFESTO

*Art is the pinnacle of human achievement.*

What sets us aside from other mammals is our ability to ponder over and articulate the reasons for our existence with life and death at its

core. The expressions of our perspectives on this perpetual enigma, and all that lies in between must serve as art's most imperative theme. The mission of an artist must include the understanding, explaining, and improvement of the human condition.

The variation of perspectives remains critical both to the progression of art and humankind, hence, to defend the right to express oneself freely should be the artist first and foremost doctrinal principle. To seek to understand shall be the lightning beacon.

### Let art be art again!

Since Marcel Duchamp's claim that a porcelain urinal is a work of art a century ago, the definition of art has become elusive to the point that anything, and then consequentially nothing, can be considered as art. What will that come to mean when a data scientist develops an algorithm that supposedly creates art? How can we even judge something we cannot really define? Therefore, this technical watershed moment we now have in front of us should be the trigger for a much needed re-boot of our artistic order and nomenclature, returning to a set of aesthetic quality standards when it comes to defining art. Aesthetic rules can be hard-coded helping us decide what is art and how to rank it, already something our predecessors clearly could articulate and were highly particular about.

If so, it would be a welcomed move; art should be represented through a minimum aesthetic standard and its motifs should aspire to advance humankind. The forms of expressions should be encouraged to be diverse and new genres welcomed but be of high quality to at all be considered. Elitist? Certainly, and if through embracing what technology does better than anyone of us will do away with second-rate artists that often are nothing more than copyists, so be it. This is a development that should be hailed as good for art.

*An aspiring artist rests on the shoulders of previous masters and their creations. Inspiration and plagiarisation are two entirely different things!*

Allowing oneself to interpret and be inspired by other works of art need not to be plagiarising if it is duly acknowledged. Indeed, learning to become an artist should include studying the great masters. But outright copying can never be art; it is theft. Currently most artificial intelligence tools only identify, re-hash, and replicate already existing patterns. Uniqueness in art should equate an idea that then is being articulated through the many genres. If artificial intelligence is used to manifest this unique idea or concept, it must be viewed as a tool that enhances art, but mere reproductions and superficial representations should be rejected as artworks. In short, for anything to count as art, it must have a purpose, an idea or concept that it wants to convey, not simply reproductions. The question of copyright and intellectual property in this regard is one that will come to plague much of the artistic community for the foreseeable future.

### Do not fight technological development, embrace it.

Technological development is a continuum, an evolvement since the invention of the wheel and is set to continue. Most, if not all, art forms include aspects of technology. But we must control technology, not the other way around; hence technology must remain an extension of us. From the tools at hand, including artificial intelligence, an artist should deploy the ones best facilitating their creative mission.

If you need to pick a fight, do not do so against the developers of technology but instead against the naysayers or the ones deploying technology with malevolent intent. Those are unfortunately plenty to choose from. It is the prerogative of the artist to advance culture and as required confront the negative and misanthropic side of an evolving world, and technology should be applied to further this cause.

### An algorithm is never responsible; ultimately it reflects its developer's intent.

Artificial intelligence is first and foremost a suite of mathematical and statistical tools and methods, and the selected sets of data these have been trained on. What artificial intelligence models currently

are doing is acting on the instructions of its human designers, creating artistic patterns based on other artistic patterns. Any attempt to create uniqueness based on a pre-conceived deliberate idea is currently not achievable within the artificial intelligence domain. It is so far a copying effort, with some variations to that, which can produce the mirage of uniqueness, however, it remains a process of replication. Thus, algorithms are being trained to identify and replicate patterns from large volumes of artworks, and then generate new ones, however still partaking in much of the same aesthetic meta standards, albeit at times applied in different artistic settings.

> *The world and us humans are much more complex than what any data patterns can replicate or express.*

Data points are just too simplistic to be able to fully capture the complexities of humans and their behaviours. No matter how advanced a model is, it is bound by assumptions that in one way or another simplifies reality, hence, unknown residuals will always remain. The construction of a model means that we either deliberately choose to omit certain factors or are not aware of them and subsequently therefore do not include them. As a model represents reality from some of its many dimensions, seeking to lift certain aspects of life that can be artistically represented, it becomes a valuable instrument for an artist in the production of art as it can help to find a unique angle and establish a distinct style.

By actively seeking to endorse a multitude of perspectives, artists can help to make sure that humanity avoids becoming slaves under a dictatorship governed by simplistic data, a historical precedent albeit a simpler version was the *New Soviet Man*. In the ongoing battle between technological simplification and the complexities of humanity, the artist must always choose the human side.

> *If and when artificial intelligence becomes truly autonomous, that is when this is going to get really interesting!*

Will an autonomous agent, likely more cognitively able than us, even be interested in art, and if so, what will its aesthetic standards be? Will we humans even be able to fathom it as art? Few now know if this ever will happen, but the artistic communities should anticipate such a situation through utilising to the full extent of what artificial intelligence currently can do so much better than us, namely unknowingly to the algorithm facilitate the bringing of serendipitous moments into life. It currently surpasses us in the generation of scenarios where it mixes and matches genres, styles, and aesthetic standards into mostly gibberish. But bound by the laws of large numbers and parameters operating on relaxed narratives, eventually it will bring out that new value-added perspective previously unthought of by us humans. Here the artist cum data scientist truly has a powerful tool at their disposal to advance art. Currently, an algorithm cannot judge and value extraordinary qualities and perspectives, it is still left to us to see the value of any uncut gems that a data combination might bring about. However, the future might be different, where artificial intelligence well knowing what it is that it is doing and selects new art styles operating on completely differing aesthetic standards, likely at a higher dimension. These representations of art might be radically different for our taste buds, perhaps even shocking. It might also combine art forms, even bringing out new ones, in ways we have never experienced before. However, we can already start to play with these conceptions through experimental design, mixture of art forms, and seeking new systematic means of defining and valuing aesthetics.

### Genuine creativity will be worth more than ever!

Creativity manifested as a new and unique way of expressing ourselves artistically is the human advantage over machines, so far. Drawing on the perceived irrationality seen as a human weakness but proven to hold the ability of finding an artistic order in chaos, such as learning how to blend the concepts of rational thinking with irrational thinking, it is clear that we still have an edge against artificial

intelligence, and there is as of yet no certainty that algorithms will catch up. The aspiration towards genuine creativity, not authoritarianism and conformism in thinking, is what not only the artistic community but also humankind at large must pursue through the educational system and through the many expressions of life. We must reject the comfort of following rules that we ourselves have set or adopted in the past and constantly seek new and innovative ways of doing things. We have to reinforce what defines us so we can better assert ourselves, communicate more effectively, and do a better job of fostering public engagement in the arts. Our greatest asset, imagination, often seen in its early stages as irrationality, as it breaks with convention, is what will advances us.

## CONCLUDING THOUGHTS

Artificial intelligence is here to stay and will continue to evolve. Trying to uninvent something even if we want to, as we sometimes have attempted to do, has in history proven a futile exercise. Albeit progress can be temporarily halted and sometimes so for a considerable length of time, technological advancements eventually win. It somehow always finds fertile ground to blossom from, not unusually brought forward through economic impetus. Artificial intelligence, fuelled through its designers' ambitious aspirations, one can convincingly argue is different versus previous breakthrough inventions, as it comes with the not unsubstantiated fear of replacing us humans as kings of the hill. It is not at all unfathomable that artificial intelligence will within a foreseeable future become autonomous and there is no lack of horror stories where this might take us. If a so-called machine-generated *superintelligence* eventually emerges, such as that proposed by Nick Bostrom *et al.*, which is thought of as an agent with a cognitive ability and performance levels that by far exceed that of even the brightest humans and are driven by motivations that can be in stark contrast to ours. There is in some camps an articulated fear that these could out-compete humans, essentially taking control over us. What can then such a contraption look like? Well, the

proponents of superintelligence have remained surprisingly silent on how it should be designed but by taking the advantage of utilising the enormous capacity of computer power, the design would likely include:

- increasing the memory capacity far beyond what is humanly possible and load it with a raft of domain expertise
- enhancing the capability of lateral association-based thinking, leveraging computer power to discover implicit knowledge and patterns from large-scale data across knowledge domains
- unlike humans, a delineation between conscious and unconscious thinking is not required
- relaxing constraints from imposed narratives so that axioms based on cultural, political, or religious doctrines that influence reasoning are removed, thus trying to achieve a truly unprejudiced view of reality rather than being coloured by various human biases

But herein lies a philosophical problem in that a superintelligence, in particular when applied to art but also societal matters and scientific paradigms, products, and solutions would likely only occasionally be accepted by the human community as they often would fall outside the boundaries of the confinements of our cognitive abilities and reigning narratives and preferences. The best way to relate to this relationship is probably to liken it with how a child has difficulties understanding the reasoning of an adult. While the axioms forming our narratives, which really are not axioms, but manmade conventions that often distorts super- and supra-rationality and lead to suboptimal solutions, albeit socially acceptable, are important parts of our human reasoning pattern, and a source of irrationality, they rarely are recognised as such. They are implicit and unspoken. So, in all likelihood, humans would, through sheer ignorance, have difficulties in dealing with superintelligence as its capacity to reason would be regarded as flawed, but not due to rules of inference but because the irrational protocols that alter and limit our perceptions of reality. However, an artist's ability to handle many different

perspectives through many different forms of expressions might quite literally provide the canvas to handle this encounter, as we did manage to do so the last time around when machines challenged us.

It appears that we are entering a future that in the truest sense of the word will be truly mind blowing, and it is the obligation of the avantgarde artist to embrace and welcome this brave new digital world!

# REFERENCES

Alexandrian, Sarane. *Surrealist Art* (London, UK: Thames & Hudson, 1970).

Antliff, Mark, Leighten, Patricia Dee. *Cubism and Culture* (London, UK: Thames & Hudson, 2001).

Ariely, Dan. *Predictably Irrational: The Hidden Forces That Shape Our Decisions* (New York: Harper Perennial, 2008).

Barnes, Sara. Artist uses AI to generate realistic faces of subjects from world's most iconic paintings (*My Modern MT*, 15 July 2020). https://mymodernmet. com/denis-shiryaev-neural-network-art/ (accessed 1 March 2021).

Bergius, Hanne. *Dada Triumphs! Dada Berlin, 1917–1923. Artistry of Polarities. Montages – Metamechanics – Manifestations* (Translated by Brigitte Pichon. Vol. V. of the ten editions of *Crisis and the Arts: the History of Dada*, edited by Stephen Foster, New Haven, CT: Thomson/Gale, 2003).

Borak, Masha. AI paintings of Chinese landscapes pass as human-made 55 per cent of the time, research by Princeton student shows (South China Morning Post, 4 December 2020). https://www.scmp.com/tech/ innovation/article/3112358/ai-paintings-chinese-landscapes-pass-human-made-55-cent-time (accessed 1 March 2021).

Borowska, Kasia. The role of AI in music curation & creation (*Forbes*, 23 September 2020).https://www.forbes.com/sites/kasiaborowska/2020/09/23/the-role-of-ai-in-music-curation--creation/?sh=73497aea6272 (accessed 1 March 2021).

Breton, André. *What is Surrealism?: Selected Writings of André Breton* (New York: Path-finder Press, Rep edition, 1978).

Brownlee, Jason. 18 Impressive Applications of Generative Adversarial Networks (GANs) (*Machine Learning Mastery*, 12 July 2019). https://machine learningmastery.com/impressive-applications-of-generative-adversarial-networks/ (accessed 1 March 2021).

Cartwright, David E. *Schopenhauer: A Biography* (New York: Cambridge University Press, 2014).

Caws, Mary Ann. *Manifesto: A Century of Isms* (University of Nebraska Press, First edition, 2000).

Church, J. Reasonable irrationality (*Mind*, 96, 1987).

Dailey, Anne C. The hidden economy of the unconscious (*Chicago-Kent Law Review*, 74(4), Symposium on Law, Psychology, and the Emotions, October 1999).

Dale, Robert. GPT-3: What's it good for? (*Natural Language Engineering*, 27(1), January 2021). https://www.cambridge.org/core/journals/natural-language-engineering/article/gpt3-whats-it-good-for/0E05CFE68A7AC8BF794 C8ECBE28AA990 (accessed 1 March 2021).

Danchev, Alex. *Modern Classics 100 Artists' Manifestos: From the Futurists to the Stuckists* (Penguin Classic, 2011).

Davidson, D. Paradoxes of irrationality (Edited by Moser, P., *Rationality in Action: Contemporary Approaches*. Cambridge, New York: Cambridge University Press, 1990).

Deahl, Dahni. AI co-produced Taryn Southern's new album (*The Verge*, August 31, 2018). https://www.theverge.com/2018/8/31/17777008/artificial-intelligence-taryn-southern-amper-music (accessed 1 March 2021).

Debord, Guy. *Report on the Construction of Situations. Situationist International Anthology* (Berkeley, CA: Bureau of Public Secrets, translated by Ken Knabb, 2006, original 1957).

Debord, Guy. *Definitions* (*Internationale Situationniste* No. 1. Paris, June 1958. Translated by Ken Knabb).

Debord, Guy. Preliminary Problems in Constructing a Situation (*Internationale Situationniste* No. 1. Paris, June 1958. Translated by Ken Knabb).

Debord, Guy. The Society of the Spectacle (*Black & Red*, 1967).

Deoras, Shrishti. The Rise and Rise of AI Gaming Industry (*Analytics India Mag*, 24 February 2021). https://analyticsindiamag.com/the-rise-and-rise-of-ai-gaming-industry/ (accessed 1 March 2021).

Dhariwal, Prafulla, Jun, Heewoo, Payne, Christine, Kim Jong, Wook, Radford, Alec, Sutskever, Ilya. *Jukebox: A Generative Model for Music* (Cornell University, 30 April 2020). https://arxiv.org/abs/2005.00341 (accessed 1 March 2021).

Duignan, Brian. Irrationalism | Philosophy (*Encyclopedia Britannica*) https://www.britannica.com/topic/irrationalism (accessed 1 March 2021).

Ehrenkranz, Melanie. Here's DALL-E: An algorithm learned to draw anything you tell it (NBC News, 27 January 2021). https://www.nbcnews.com/tech/innovation/here-s-dall-e-algorithm-learned-draw-anything-you-tell-n1255834 (accessed 1 March 2021).

Eksteins, Modris. *Rites of Spring* (Boston, MA: First Mariner Books edition, 2000, original 1989).

Eliza Strickland. OpenAI's GPT-3 Speaks! (Kindly Disregard Toxic Language) (*IEEE Spectrum*, 1 February 2021). https://spectrum.ieee.org/tech-talk/artificial-intelligence/machine-learning/open-ais-powerful-text-generating-tool-is-ready-for-business (accessed 1 March 2021).

Ford, Simon. *The Situationist International: A User's Guide* (London, UK: Black Dog, 2004).

Fujishima, Kenji, Gahaku, AI. *Your Latest Artificial Intelligence Art Obsession* (*Fine Art Globe*, 6 April 2020). https://fineartglobe.com/news/ai-gahaku-your-latest-artificial-intelligence-art-obsession/ (accessed 1 March 2021).

Gaut, Berys. The cluster account of art defended (*British Journal of Aesthetics*, 45, 2005).

Gault, Matthew. Artist Uses AI to Recreate 'Watermelon Sugar' Music Video Using Footage of Ronald Reagan (*Vice Motherboard*, February 17, 2021). https://www.vice.com/en/article/4ad8ew/artist-uses-ai-to-recreate-watermelon-sugar-music-video-using-footage-of-ronald-reagan (accessed 1 March 2021).

Gieser, Suzanne. *The Innermost Kernel: Depth Psychology and Quantum Physics. Wolfgang Pauli's Dialogue with C. G. Jung* (Berlin Heidelberg, Germany: Springer Verlag, 2005).

Gödel, Kurt. *Über formal unentscheidbare Sätze der Principia Mathematica und verwandter Systeme, I* (*Monatshefte für Mathematik und Physik*, 38, 1931).

Golomstock, Igor. *Totalitarian Art in the Soviet Union, the Third Reich, Fascist Italy and the People's Republic of China* (Harper Collins, 1990).

Goodfellow Ian J, Pouget-Abadie Jean, Mirza Mehdi, Xu Bing, Warde-Farley David, Ozair Sherjil. Courville Aaron, Bengio Yoshua. *Generative Adversarial*

*Networks* (Cornell University, 10 June 2014). https://paperswithcode.com/method/gan (accessed 1 March 2021).

Gwern Branwen. William Shakespeare. Transformer AI poetry: Poetry classics as reimagined and rewritten by an artificial intelligence (*GPT-3 Creative Fiction*, 28 September 2020). https://www.gwern.net/GPT-3#william-shakespeare (accessed 1 March 2021).

Hao, Karen. Inside the world of AI that forges beautiful art and terrifying deepfakes (*MIT Technology Review*, 1 December 2018). https://www.technologyreview.com/2018/12/01/138847/inside-the-world-of-ai-that-forges-beautiful-art-and-terrifying-deepfakes/ (accessed 1 March 2021).

Hao, Karen. Create your own moody quarantine music with Google's AI (*MIT Technology Review*, 4 September 2020). https://www.technologyreview.com/2020/09/04/1008151/google-ai-machine-learning-quarantine-music/ (accessed 1 March 2021).

Hart, Matthew. *This 'Jukebox' AI Generates Complete Songs* (Nerdist, 5 May 2020). https://nerdist.com/article/jukebox-ai-generates-complete-songs/ (accessed 1 March 2021).

Heaven, Will Douglas. OpenAI's new language generator GPT-3 is shockingly good—and completely mindless (*MIT Technology Review, Artificial Intelligence/Machine Learning*, 20 July 2020). https://www.technologyreview.com/2020/07/20/1005454/openai-machine-learning-language-generator-gpt-3-nlp/ (accessed 1 March 2021).

Jhala, Kabir. An AI bot has figured out how to draw like Banksy. And it's uncanny (*The Art NewsPaper*, 23 October 2020). https://www.theartnewspaper.com/news/ai-generates-fake-banksy-algorithm (accessed 1 March 2021).

Kaufmann, Walter. *Nietzsche: Philosopher, Psychologist, Antichrist* (Princeton University Press, 1974).

Khalili, Joel. AI will soon outperform us in disciplines we thought were uniquely human (*TechRadar*, 23 January 2021). https://www.techradar.com/in/news/ai-is-on-the-verge-of-mastering-the-creative-arts (accessed 1 March 2021).

Lyon, Janet. *Manifestoes: Provocations of the Modern* (Cornell University Press, First edition, 1999).

Mannoni, Octave. *Freud: The Theory of the Unconscious* (London, UK: Verso, 2015, original 1971).

Marinetti, Filippo Tommaso. *Manifesto of Futurism* (original 1909) in Lynton, Norbert. *Futurism* (edited by Nikos Stangos, *Concepts of Modern Art: From Fauvism to Postmodernism* (3rd edition. London, UK: Thames & Hudson, 1994)).

Marinetti, Filippo Tommaso. *Critical Writings* (edited by Günter Berghaus, New York: Farrar, Straus, and Giroux, 2006, original 1911).

Marinetti, Filippo Tommaso. *Technical Manifesto of Futurist Literature* (original 1912) in (edited by White, John J. *Literary Futurism: Aspects of the First Avant Garde* (Oxford, UK: Clarendon Press, 1990).

Mead, Margaret. *Male and Female* (New York: Harper Perennial, 2001 ed, 1949 org).

Mehta, Ivan. Google's new machine learning tool turns your awful humming into a beautiful violin solo (*The Next Web*, 1 October 2020). https:// thenextweb.com/neural/2020/10/01/googles-new-machine-learning-tool-turns-your-awful-humming-into-a-beautiful-violin-solo/ (accessed 1 March 2021).

Miah, Andy. *A Critical History of Posthumanism* (edited by Gordijn, B. & Chadwick, R. Medical Enhancement and Posthumanity. Springer, 2008).

Miller, Arthur I. *DeepDream: How Alexander Mordvintsev Excavated the Computer's Hidden Layers* (The MIT Press Reader, 1 July 2020). https://thereader.mitpress.mit. edu/deepdream-how-alexander-mordvintsev-excavated-the-computers-hidden-layers/ (accessed 1 March 2021).

Music Ally. Loudly shows off AI tech to remix songs into different genres (*Music ally*, 5 March 2020). https://musically.com/2020/03/05/loudly-shows-off-ai-tech-to-remix-songs-into-different-genres/ (accessed 1 March 2021).

Nelson, Daniel. OpenAI Creates New AI Program To Create Music Based On Genres (*Unite.AI*, 3 May 2020). https://www.unite.ai/openai-creates-new-ai-program-to-create-music-based-on-genres/ (accessed 1 March 2021).

Nichols, Greg. AI can write a passing college paper in 20 minutes (*ZDNet*, 24 February 2021). https://www.zdnet.com/article/ai-can-write-a-passing-college-paper-in-20-minutes/ (accessed 1 March 2021).

Plant, Sadie. *The Most Radical Gesture* (New York: Routledge, 1992).

Prokhorov, Gleb. *Art under Socialist Realism: Soviet Painting, 1930 - 1950* (East Roseville, NSW, Australia: Craftsman House; G + B Arts International, 1995).

Radford, Alec, et al. Learning Transferable Visual Models From Natural Language Supervision (*Open AI*, 5 January 2021). https://cdn.openai.com/

papers/Learning_Transferable_Visual_Models_From_Natural_Language_Supervision.pdf (accessed 1 March 2021).

Richter, Hans. *Dada: Art and Anti-art* (New York and Toronto: Oxford University Press, 1965).

Ronald W. Clark. *Freud: The Man and the Cause* (Random House Inc, first edition, 1980).

Seabrook, John. The Next Word. Where will predictive text take us? (*The New Yorker*, 14 October 2019). https://www.newyorker.com/magazine/2019/10/14/can-a-machine-learn-to-write-for-the-new-yorker (accessed 1 March 2021).

Simon, Herbert A. *Models of Man: Social and Rational- Mathematical Essays on Rational Human Behavior in a Social Setting* (New York: John Wiley, 1957).

Simonite, Tom. Did a Person Write This Headline, or a Machine? (*Wired*, Business 22 July 2020). https://www.wired.com/story/ai-text-generator-gpt-3-learning-language-fitfully/ (accessed 1 March 2021).

Smith, John R. IBM Research Takes Watson to Hollywood with the First "Cognitive Movie Trailer" (*IBM Blogs*, Cognitive Computing, 31 August 2016). https://www.ibm.com/blogs/think/2016/08/cognitive-movie-trailer/ (accessed 1 March 2021).

Stein, Edward. *Without Good Reason: The Rationality Debate in Philosophy and Cognitive Science* (Oxford, UK: Oxford University Press, 1996).

The Economist. A new AI language model generates poetry and prose (*The Economist, Science & Technology*, 8 August 2020). https://www.economist.com/science-and-technology/2020/08/06/a-new-ai-language-model-generates-poetry-and-prose (accessed 1 March 2021).

Toth, C. Rationality and irrationality in understanding human behaviour. An evaluation of the methodological consequences of conceptualising irrationality (*Journal of Comparative Research in Anthropology and Sociology*, 4(1), Summer 2013).

Turing, Alan. Computing machinery and intelligence (*Mind - A Quarterly Review of Philosophy and Psychology*, LIX(236), October, 1950).

Vietta, Silvio. *A Theory of Global Civilization: Rationality and the Irrational as the Driving Forces of History* (Amazon Digital Services LLC, 2013).

Zehr, E. Paul. *Inventing Iron Man: The Possibility of a Human Machine* (Johns Hopkins University Press, 2011).

# INDEX